Master Posing Guide

FOR CHILDREN'S PORTRAIT PHOTOGRAPHY

Norman Phillips
AMHERST MEDIA, INC. ■ BUFFALO, NY

■ About the Author

Norman Phillips was born in London, England and became a U.S. resident in 1980. He is married, has three sons, and lives in Highland Park, Illinois. The Norman Phillips of London Photography studio, located in Highland Park, Illinois, was established in 1983.

Throughout his career, Norman has been a judge at local, regional, and international print competitions and has presented almost 200 seminars and workshops. He is a frequent contributor to several magazines and newsletters, including *Rangefinder, Professional Image Maker, Master Photographer, and WPPI Monthly.* He has created eight instructional and educational video titles, instructional manuals, and is the author of *Lighting Techniques for High Key Portrait Photography, Lighting Techniques for Low Key Portrait Photography, Wedding and Portrait Photographers' Legal Handbook, Professional Posing Techniques for Wedding and Portrait Photographers, and Advanced Studio Lighting Techniques for Digital Portrait Photographers,* all from Amherst Media. Norman has created more than 240 images that have earned a score of 80 or better, ten Best of Show ribbons, and many First Place Awards in various competitions.

Norman is also the recipient of a wide range of honors for his photographic achievements.

For more information, see www.NormanPhillipsofLondon.com.

Amherst Media®
P.O. Box 586
Buffalo, N.Y. 14226
Fax: 716-874-4508
www.AmherstMedia.com

Publisher: Craig Alesse
Senior Editor/Production Manager: Michelle Perkins
Assistant Editor: Barbara A. Lynch-Johnt

ISBN-13: 978-1-58428-191-7
Library of Congress Control Number: 2006925659
Printed in Korea.
10 9 8 7 6 5 4 3 2 1

Notice of Disclaimer: The information contained in this book is based on the author's experience and opinions. The author and publisher will not be held liable for the use or misuse of the information in this book.

Contents

Introduction

There are numerous books on the market that are devoted to posing for portrait and wedding photography, but this may be the first that deals with the more challenging task of posing children. When I suggest that posing children can be challenging, I think that many of you understand exactly what I mean. Oftentimes, the notion of posing children is a misnomer, especially when we are working with little people yet to reach their third birthday.

Working with older subjects who are able to understand some direction is generally much easier. But those tiny subjects have little or no concept of what we are aiming to achieve, no matter how much we apply our experience and manipulative skills. Another reason for some of our difficulties is that the youngest of our subjects have limbs that appear not to be connected to their owner's brain and gesticulate and make signs that are entertaining and often hysterically funny, even if that's not what we want.

As we work our way through the various age categories, we will demonstrate ways to overcome most, if not all, the challenges by providing practical methods that at least give a place from which to begin.

Though the chapters are organized into discrete age categories, we must remember that there are often noticeable differences in each subject's physical and mental abilities. As such, we need to assess each subject and not assume that because they are a specific age they will be like any other subject of that age.

■ About this Book

In my previous book, *Professional Posing Techniques for Wedding and Portrait Photographers,* I included a brief reference to posing children—and as you work through this book, you will see that this is because posing young subjects is simply not the same as working with adults. In sporting vernacular, it's a different ball game.

At print exhibitions and in books dedicated to children's portraits, we see some beautiful images. Yet most of these do not show us how to pose little people in a practical manner that also evokes our emotions and makes moms, dads, and grandparents ooh and ahh.

In this book we will review many options and ideas for effectively posing children—from babies through early teens—and will consider the philosophy behind posing young subjects. While many of my own images appear in the book, many of the portraits herein were created by other highly competent and successful photographers and, as such, you will see a wide array of posing ideas that are reliable and very workable.

As you peruse the images, you will see that a variety of props and backgrounds have been employed. Remember to make your images with props and backgrounds that appeal to you and your market so that what you produce is representative of your photography and not simply a carbon copy of others' images.

If you are like me, you undoubtedly take great pleasure in working with children and babies. With the help of this book, I think you will find that photographing young subjects will become increasingly enjoyable and exciting, and your portraits more successful.

■ Contributing Photographers

Without these talented contributors' images, this book would not have been possible. Their images will help you to recognize the level of expertise and creativity

that photographers are now bringing to children's portraiture.

Joanne Alice. Joanne Alice has four Best of Show Awards from Chicagoland Professional Photographer's Association (CPPA) and has won the association's coveted Print of the Year Award four times. She has also received the People's Choice Award at the association's annual convention. Joanne is the four-time winner of the CPPA Hoyt Portrait Award and is a CPPA Certified Professional Photographer.

Kerry Firstenberger. Kerry Firstenberger has trained with and worked alongside Norman Phillips for nine years. She has hung prints at WPPI print competitions and has won First Place Awards from CPPA.

Sam Lanza. Although Sam Lanza has not received his PPA Masters degree at the time of this writing, his work is of an exceptionally high standard.

Karen Rodgers. Karen Rodgers is a PPA Master Photographer with numerous awards including Photographer of the Year, Associated Professional Photographers of Illinois Top Ten, and PPANI Best of Show ribbons.

Cindy Romano. Cindy Romano has a PPA Masters degree. She is also a PPA Certified Professional Photographer and a PPA Affiliate Judge. In 2005, she was one the Top Ten photographers in Illinois. Cindy has hung portraits at Epcot Center and has had prints selected four times for the PPA Loan Collection.

Julia Stotlar. Julia is the daughter of master photographer Karen Rodgers. She has clearly inherited her mother's ability to create outstanding portraits.

Wendy Veugeler. Wendy Veugeler holds a PPA Masters degree and is a PPA Certified Professional Photographer and has a Fellowship with PPANI. Her Awards include the Kodak Gallery Award, Fuji Masterpiece Award, PPA Loan Prints, and PPA Photographer of the Year Award/Silver.

1. Babies and Toddlers

In this chapter, we deal with babies and toddlers. We will turn our attention first to babies too young to sit or stand. While most infants can partially support themselves at about four-and-a-half months, many are a little slower getting to that point in their development. These little people are likely to be laying down on their back or stomach, possibly resting on their elbows. At this age some are also able to crawl.

WHEN POSING BABIES FROM BIRTH THROUGH FIVE MONTHS, WE MUST MEET A UNIQUE SET OF CHALLENGES.

Babies who are able to sit but not stand, even with something to hold on to, are covered next.

Moving along, we turn our attention to working with tots from about twelve months to twenty-four months. At this age, children are able to stand without something to hold on to and are walking for the first time—and that is about all they want to do!

Small children in the toddler age range, about twenty-four months to age four, are covered next. If you have heard the expression "terrible twos," then you know what to expect. Individuals in this age group seem to be the most willful of all the categories and are the most difficult to "trap"—photographically speaking—in just the place we need them to be.

■ Birth to Five Months

When posing babies from birth through five months, we must meet a unique set of challenges. Because these tiny subjects cannot take instruction and often wriggle out of any position we place them in, our main objective is to create the best-possible view. This is typically done using a variety of props that present the baby at a desirable angle to the camera, though once a baby can push up on their hands or elbows, floor poses can be effective too.

Photographing babies in a basket is fairly common, but doing so with style will help create an image that is both creative and beautiful. In plate 1, we have a standout portrait by Cindy Romano. Note that the tiny subject is presented in a perfectly normal position, and that a blanket was used as a cushion to ensure the baby's comfort. An uncomfortable baby will not be

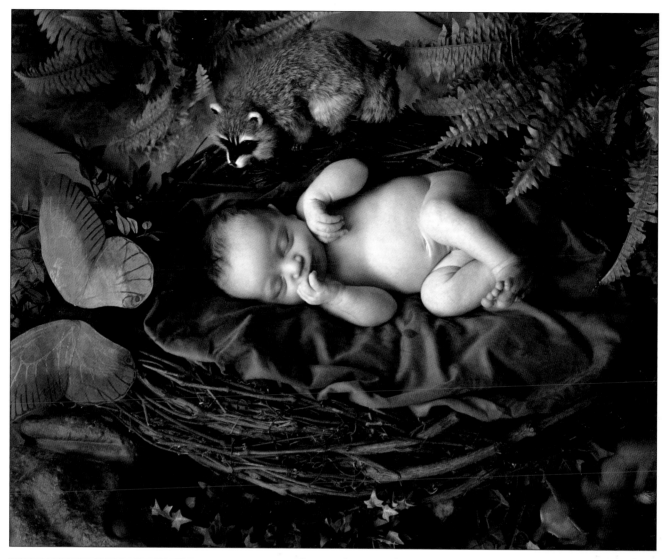

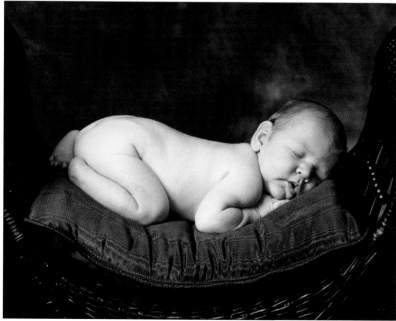

Above—Plate 1. Photo by Cindy Romano. **Left**—
Plate 2. Photo by Wendy Veugeler.

happy, and the results will be less than pleasing. Cindy enhanced the set by using stuffed animals and foliage.

In plate 2, Wendy Veugeler reversed the style that Cindy Romano used in plate 1. Here, the subject was positioned on its tummy on a cushioned seat that sweeps upward at each end and caused the baby to curl up in a snuggle position.

In plate 3, we have a pose that required us to position the camera almost directly above the baby to prevent a distorted perspective. In this image, the baby was simply laying on a comfortable quilt and was

covered by a blanket. Important here is that baby's feet protrude from under the cover. This provides mom the ability to see those precious feet and also lengthens the portrait, a feature that will enable us to enlarge it to a wall-sized portrait. We brought in some artificial flowers to add color and texture to the image and enhance the composition.

In plate 4, we have a different view of a baby laying down in a similar set. The camera was positioned at the baby's eye level. We must be careful not to expose a baby's private parts to the camera. To prevent this, we placed a blanket between the baby's legs and drew it over the far hip.

*Top—*Plate 3. ***Bottom—****Plate 4. Photos by Norman Phillips.*

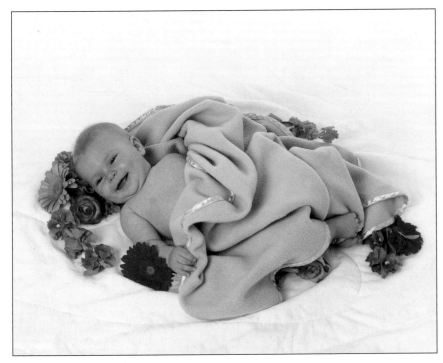

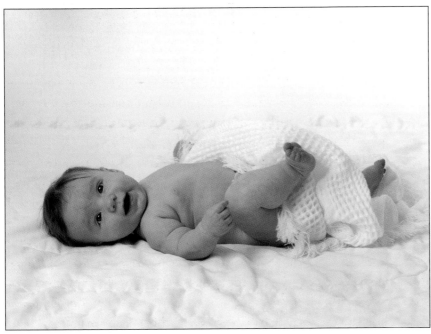

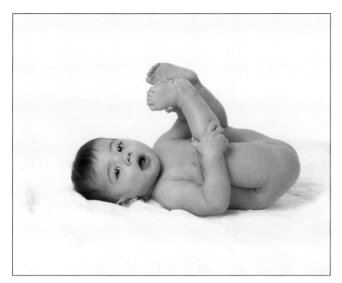

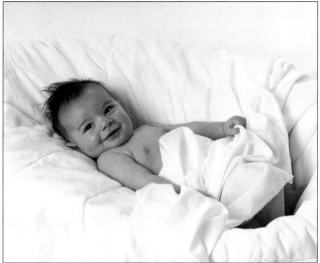

*Above left—Plate 5. Above right—Plate 6.
Photos by Norman Phillips. Right—Plate 7.
Photo by Sam Lanza.*

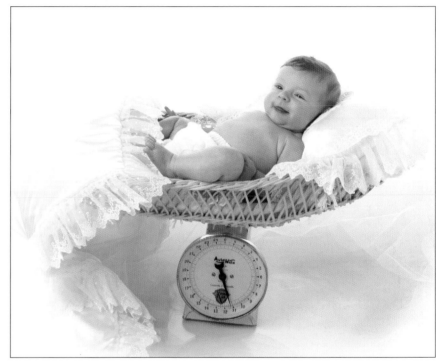

In plate 5, we have a portrait of a naked baby about four months old. The angle of view we used in this case prevented us from exposing to the camera parts of the body that we should not show.

Plate 6 shows a portrait of a baby positioned in a bassinet, a supportive prop that works a little better than a basket when the baby is alert and active. The bassinet was covered with soft quilts to maximize the baby's comfort. This arrangement allowed for a nice presentation.

Plate 7, a portrait by Sam Lanza, shows how the bowl shape of a scale can be used to hold the baby. Sam placed a blanket and a pretty pillow under the baby to ensure the little subject's comfort. While white accessories were employed in this case, you can certainly tailor your choice of fabric and colors to suit the baby's gender or the parents' decor.

To create the image shown in plate 8, Joanne Alice placed a pillow on top of a baby mattress and added an elegant, textural pillow to uplift the baby's head and shoulders. In this image, the baby's shoulders were positioned at the base of the pillow. If the pillow is particularly soft, the baby's shoulders can be positioned a little higher. This will allow a gentle slope in the baby's position and prevent him or her from having too sharp a bend at the neck or waist. If a pillow is too firm and the baby does not have its head and shoulders on the pillow, the chin will be forced down onto the chest, and the baby will be most uncomfortable—and unhappy.

Plate 8. Photo by Joanne Alice.

Note that Joanne concealed the subject's pelvic area with a blanket. Employing this strategy will allow you to create a modest image if the baby is nude, or to cover up a diaper for a more stylized look.

Plates 9 through 11 show images Joanne Alice created of a five-month-old boy. In plate 9, he is seen nestled in luxurious white bedding. This presentation allowed him to stretch his arms out. Note the curved shape of the platform. If the curve were too deep, the baby would not be able to stretch, as his arms would be locked in.

For plate 10, Joanne placed the baby on his tummy, and he pushed up and raised his head (most babies can do this at about five months of age). When creating an image like this, remember that the set should be firm; if it is too soft, the baby's arms and shoulders may be obscured by the fabric.

In plate 11, we see that the baby pushed up onto his hands with a blanket over his head. This pose is always popular, especially because at five months, this is possibly a new accomplishment. In this image we can see the baby's diaper, but because it is so far back and slightly less illuminated, it is not a negative element in the portrait.

It is wise to ensure that the base on which the subject is posed is cushioned in case the little person's arms give way and he falls on his face, which sometimes can happen.

In plate 12, Sam Lanza used a sloping prop that allowed this tiny child to push himself up onto his forearms. Most babies this age are likely to push down on the prop's trap with their feet, but younger babies may need

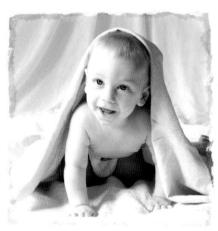

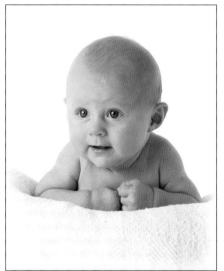

Top left—Plate 9. **Center**—Plate 10. **Top right**—Plate 11. *Photos by Joanne Alice.* **Bottom left**—Plate 12. **Bottom right**—Plate 13. *Photos by Sam Lanza.*

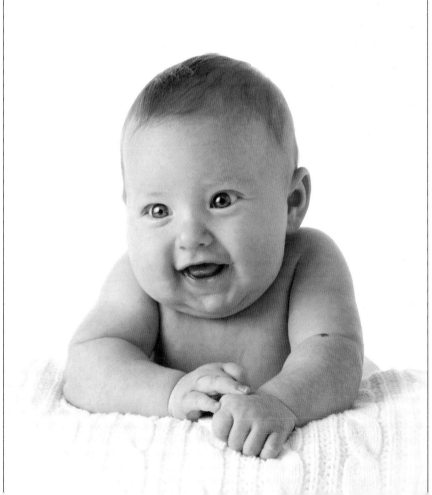

to be repositioned when they slide. There are several prop companies that sell this style of prop, including Wicker by Design, Pro Studio Supplies, and Far West, to name a few.

The sloped prop Sam used in plate 13 is less steep and allowed baby to rest on his elbows and hands with a lower risk of sliding down. Because the slope is less pronounced, baby may also be more comfortable with this type of prop. When choosing between the available sloping props, consider the stage of development of your subject. Always remember that babies mature at different rates.

To create the image shown in plate 14, Sam used yet another variation of the sloping prop. The one shown here is much closer to a floor position; it is ideal for a baby less than four months but will easily accommodate infants up to five-months-old. Remember, though, the older the baby, the less likely he or she will remain in the desired position.

Plate 15 shows a portrait of a three-month-old positioned on a prop similar to that shown in plate 12. The pose was originally designed so that both arms would appear in the position of the left arm, but the subject unexpectedly moved his arms, and as a result, the right arm was posed farther back.

In plate 16, the subject is shown on a prop with a slope of 45 degrees. A 45-degree slope is advantageous: When the slope is too pronounced, baby will slide down and we will have to continually reset the pose. When the slope is too shallow, the angle of view will be boring and create a slim composition that will produce a lot of empty space within the frame.

Plate 17 shows a baby between four and five months of age in a simple floor pose. Baby is capable of pushing up and showing his strength and alertness. Some babies at this age can roll over onto their side or back and present you with the opportunity to get a variety of images that document this stage of their development.

Left—Plate 14. Photo by Sam Lanza.
Right—Plate 15. Photo by Norman Phillips.

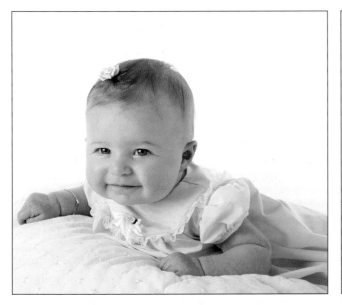

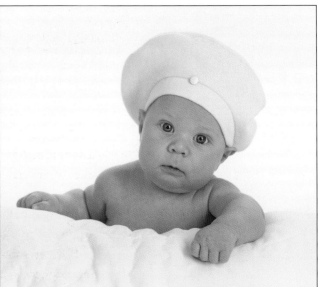

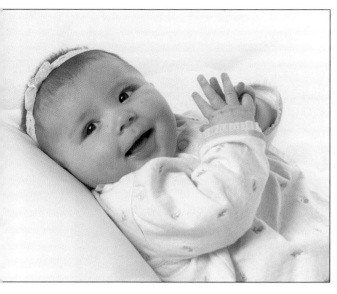

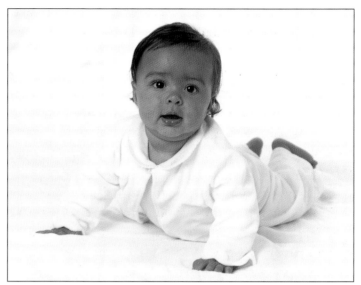

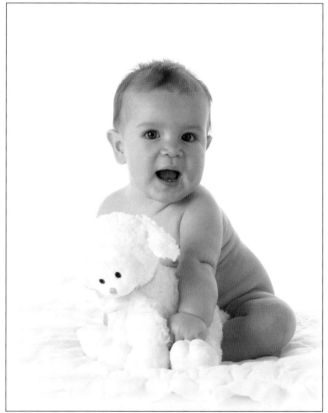

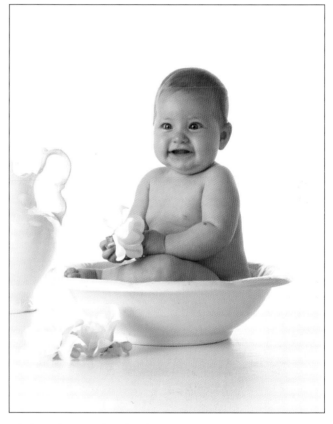

Top left—Plate 16. *Top right*—Plate 17. *Photos by Norman Phillips.* *Above left*—Plate 18. *Above right*—Plate 19. *Photos by Sam Lanza.*

Plate 18 shows a baby who was barely able to sit without support. Sam Lanza presented the baby with a stuffed animal to lean against. At this early age, babies can easily fall backward or forward. Though she could still topple over in any direction, this form of support allowed Sam to capture several images before needing to reset the pose. Ensure that baby is surrounded by lots of soft materials so if she topples, she won't be harmed.

Plate 19 shows a Sam Lanza portrait in which a baby, old enough to sit independently, was posed in a washbasin. This is a relatively popular posing prop. Because of its relative depth, the back of the bowl tends to hug the

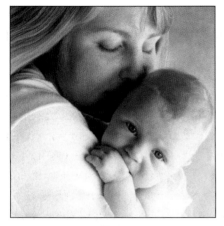

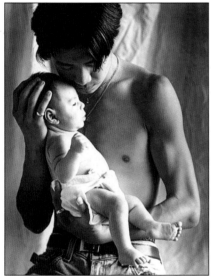

baby's hips, increasing stability and allowing the baby to sit independently for at least a short time.

While we won't focus on mother-and-baby or father-and-baby portraiture in this book, sometimes getting portraits of a baby is not feasible unless we enlist the help of mom or dad. Sometimes we include a parent in an image to support the baby; other times, we call on a parent to spark the baby's attention when he or she is not responsive to our coaching.

In this portrait style it is important to get your camera perspective right or you will be unable to clearly see baby and mother. The ideal angle for the subject is approximately 45 degrees to the plane of the camera. The camera should be focused on baby, but we also want a flattering view of the parent. In plate 20, Joanne Alice got the shot dead right. Note how the mother was turned toward the baby so that we see her nicely presented and she is not simply a prop but an integral part of the portrait. Mothers sometimes want to be a prop—and not to appear in the image—but this frequently results in images that are not presentable.

*Top left—Plate 20. **Above**—Plate 21. **Bottom left**—Plate 22. Photos by Joanne Alice.*

In plate 21, all focus is on the subject of the portrait, as only the parent's hands appear in the image. Joanne Alice's image was made in an unusual style that is highly effective as it has the baby in a wide-eyed pose. In this style of portrait it is important not to show the person holding the baby, so the perspective of the camera is critical. One way to achieve this is to have the parent lay or sit down and hold the baby up. A second and perhaps more common way to achieve this result is to have the parent positioned slightly to one side of the baby with his or her arms outstretched. This may mean having one of his or her arms bent to ensure they are not visible in the image. The tight crop Joanne used makes this image very effective.

Joanne also created the image shown in plate 22. Note how the man has baby seated in the palm of his hand and is supporting the infant's back with his other hand and arm. Joanne ensured that the viewer's eye is first drawn to the baby by presenting the adult in a lower key.

Young babies spend most of their time sleeping, so we inevitably face photographing sleeping babies on occasion. When this is the case, the pos-

Plate 23. Photo by Cindy Romano.

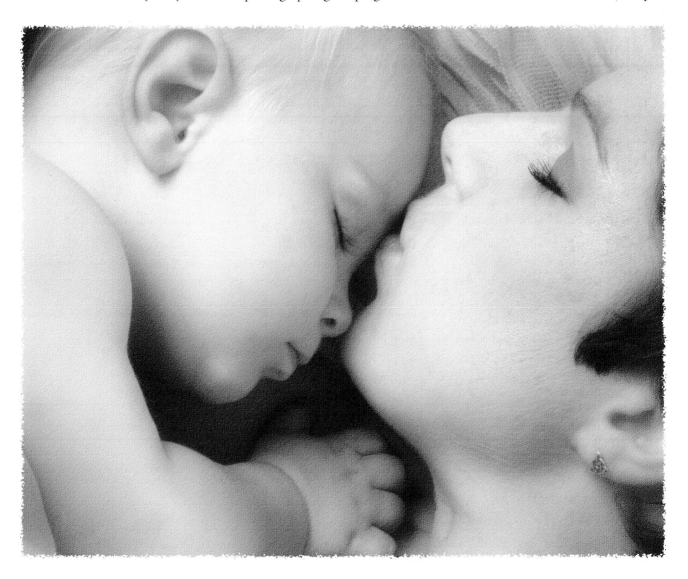

ing concept used by Cindy Romano in plate 23 is most appropriate. Cindy had both mother and infant laying down and very close. Baby was very comfortable and secure in this position and, while asleep, presented a delightful portrait. (Additionally, some wakeful babies are much calmer when close to mother.) While mother is visible in the portrait, baby is more prominent in the frame.

Plate 24 shows a baby dressed in her christening gown. Her mother wanted to show her in a seated pose but also wanted to show the full length of the gown. This presented a challenge, because photographing the baby laying down would create a perspective problem unless we photographed her from high above. So we came up with the idea of seating baby on a high stool, with the support of a person positioned behind the drapes who held tightly onto the gown and provided the needed support. We also had the baby hold onto the drape, which added to the composition and her safety.

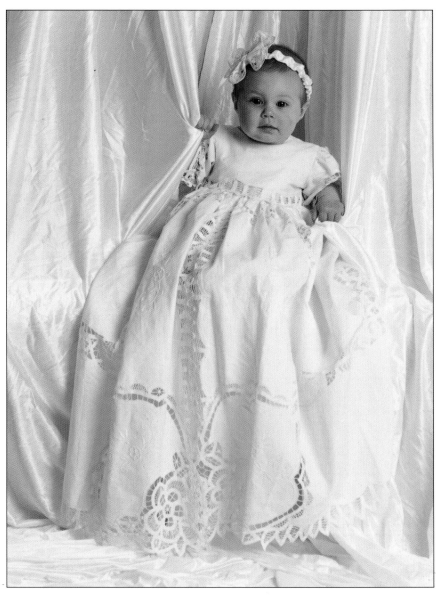

Above—Plate 24. Photo by Norman Phillips. **Facing page***—Plate 25. Photo by Cindy Romano.*

■ Six Months to One Year

With babies six months and over we have many more options in creating delightful portraits. Once a baby is able to sit without support and also stand with or without support our creativity is virtually unlimited. We show some of the most basic poses in this section.

In plate 25, we have an image by Cindy Romano, who photographed an infant who was able to sit without support. The baby was positioned in front of a mirror and was quite excited to see her reflection; this allowed her to produce a real parent-pleasing image. At this age, we should seek to have baby actively involved in the photographic process. We want our little subjects to show their newest skills and interests, and anything we can do to get them to react will improve the portrait.

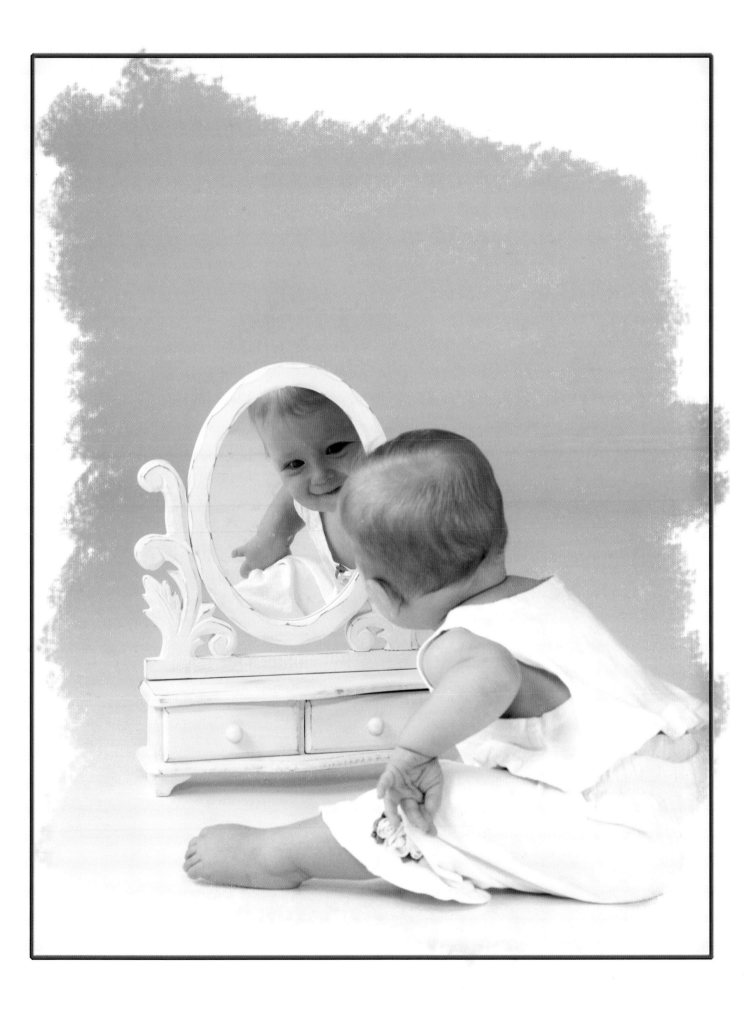

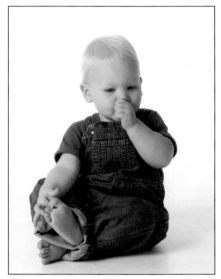

Plate 26, a portrait by Julia Stotlar, shows a confident baby of about eight months of age seated on the floor. Providing an object that holds baby's attention, like the teething ring shown in this image, will help to ensure he is in a stable pose. When baby's interest in the object wanes (and this may take just a couple of minutes), it's time to introduce another object of interest.

Because Julia positioned the baby at a 35-degree angle to the camera, we can see both legs. If he were placed in full profile, he would create an L-shaped image, which would be much less interesting.

In plate 27 we have a portrait by Kerry Firstenberger. Once the baby was seated, he immediately put his thumb in his mouth and reached for his toes, so there was no need to introduce an object to grab his attention.

Plate 28 shows a girl about seven- to eight-months-old occupied with a basket of flowers. Kerry Firstenberger had this little girl attend to the flow-

Left—Plate 26. Photo by Julia Stotlar.
Above—Plate 27. Photo by Kerry Firstenberger.

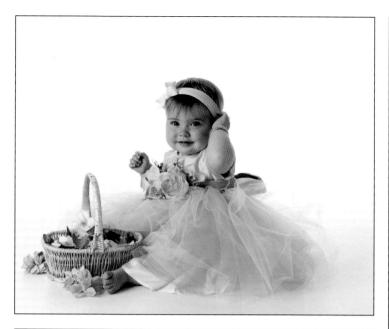

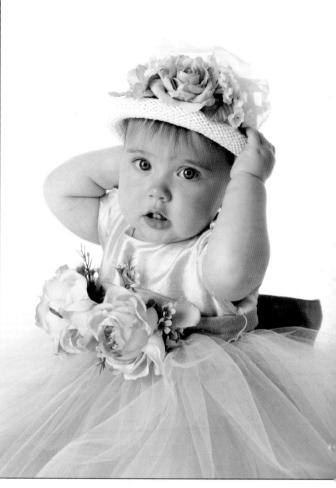

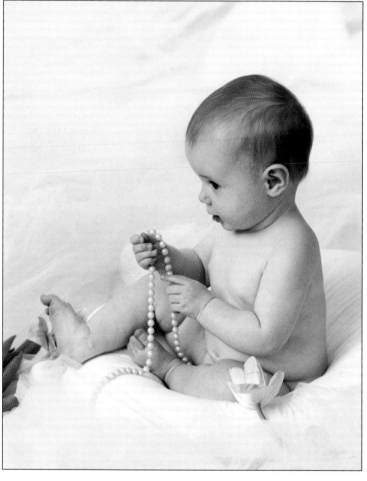

Top left—Plate 28. *Top right*—Plate 29. *Photos by Kerry Firstenberger.* *Left*—Plate 30. *Photo by Wendy Veugeler.*

ers to produce an image of a dainty little lady in a pretty dress and a bow in her hair—and not rolling around and crawling on all fours. This is another example of using objects to keep the attention of babies who would otherwise not stay in one place.

Kerry used a different technique to engage the child in order to create the portrait shown in plate 29. Placing a hat on a child's head will almost always result in the child trying to remove it. As those events unfolded here, Kerry zoomed in for this close-up portrait. We can have a lot of fun with this strategy, capturing images of great humor as the baby seeks to remove the hat or tries to discover what is on his or her head.

A string of pearls and a baby girl are compatible image elements, as Wendy Veugeler shows us in plate 30. In this image, the pearls captured the

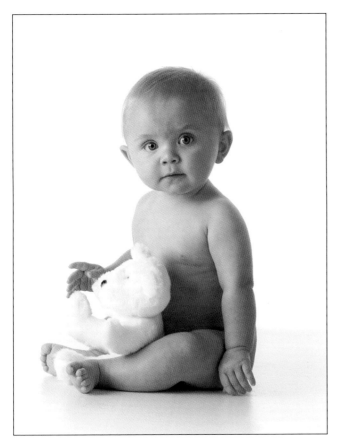

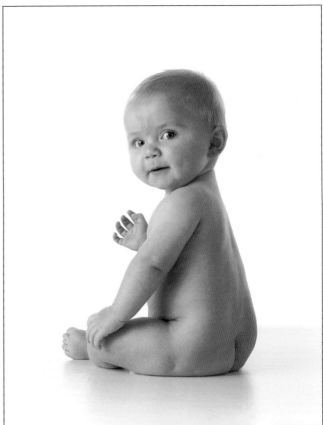

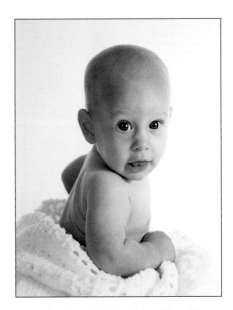

baby's interest, resulting in a very pleasant portrait. Often, though, when the baby's attention is fixed on such a prop it is difficult to get them to answer our calls for their attention.

Sam Lanza created the image shown in plate 31. He placed a stuffed animal between the baby's legs, which helped to make him comfortable and provided something he could relate to if he lost interest in what was happening behind the camera. Ideally the toy should be one that the baby is familiar with, so parents should be advised to bring such items to the session.

Baby was placed in profile to the camera, and when his attention was called he delightfully expressed his interest. While the stuffed animal shown here piqued this baby's interest, keep in mind that blankets, toys, and colorful objects can work equally well. We need to remember that what might be unexciting to us is new and interesting to the baby who is still exploring the world.

In plate 32, Sam Lanza cleverly changed the pose of the baby shown in plate 31. Babies are inherently curious, and by turning this little fellow away from the camera he naturally turned his head to see what was going on near the camera. This resulted in a delightful expression as he recognized someone near the camera.

Plate 33 achieves the same result. In this portrait, baby was turned even farther away from the camera than in the previous image. In this instance,

*Top left—Plate 31. **Top right**—Plate 32. Photos by Sam Lanza. **Above**—Plate 33. Photo by Norman Phillips.*

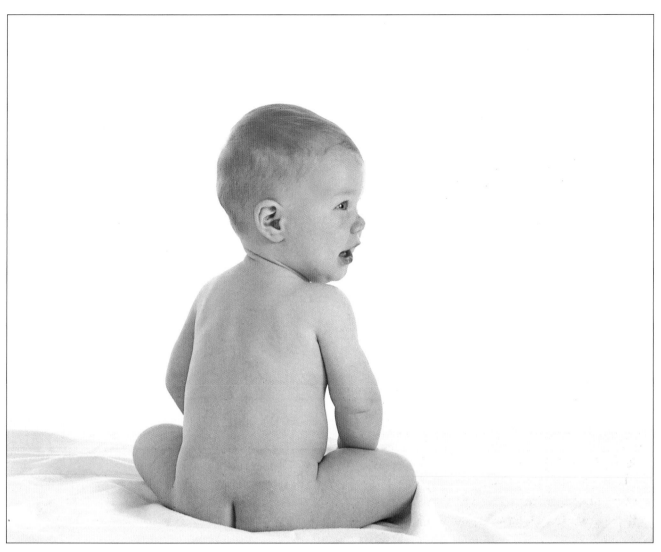

Above—Plate 34. **Right**—*Plate 35. Photos by Norman Phillips.*

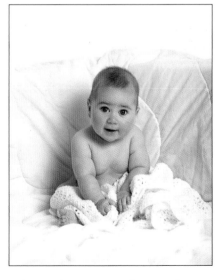

a blanket was placed around the little boy, and when his name was called he made a very strong turn toward us. Plates 32 and 33 demonstrate how we can take advantage of a baby's curiosity and desire to know what's going on.

Plate 34 shows the result of photographing a baby in a position similar to the one used to create the portrait shown in plate 33.

Plate 35 is a straightforward and simple example of a six- to eight-month-old seated with a blanket in his lap. Keep in mind that a blanket can be used to ensure that we do not see a diaper or, if the baby is naked, his or her private parts. When we set this portrait up we were not sure if he would be able to stay seated, and the

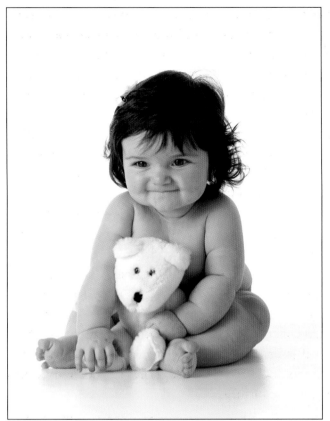

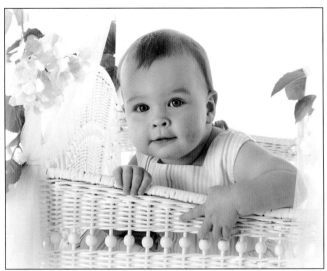

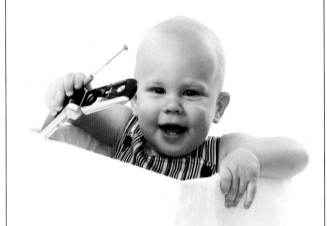

two boxes with quilts were placed behind him for safety's sake.

Plate 36, a Sam Lanza portrait, shows a delightful little lady who was photographed at a very slight angle to the camera—just enough to allow us to have a less head-on view. Sam again used the stuffed animal to engage the subject, and its soft texture was a big hit. We need to remember that babies react to how things feel almost as much as they react to sounds and things they see.

Left—Plate 36. **Top right—***Plate 37. Photos by Sam Lanza.* **Bottom right—***Plate 38. Photo by Joanne Alice.*

Generally, babies less than eight-months-old are unable to stand, though some can do so when holding on to a chair, box, or other prop. Sometimes we need to corral small people because they insist on crawling out of our set, so we use a box, crib, or large basket. The baby is placed in the prop and will generally seek to either climb out or simply let us know how they feel about their captivity. Occasionally baby will get mad and protest, perhaps cry, but mostly they will present themselves as in plate 37, a Sam Lanza portrait. This is a very pleasant view of a baby with a calm temperament. The camera perspective in this portrait is notable as it is not square to the plane of the crib.

Another example of this technique is shown in plate 38, a portrait by Joanne Alice. The little person was very happy with his phone and wanted us to know about it. The box around him caused him to bring his hands and arms into view as he expressed himself.

Wendy Veugeler sat the little girl shown in plate 39 on a chair with arms that were close to the child so that if she needed to reach for support it was close by. This chair and similar styles are available from various suppliers. Note that the child's feet were positioned slightly to the left and were not on the same plane as her head. This should be our goal whenever possible, as breaking this line will provide a more dynamic pose.

To create the portrait shown in plate 40, Sam Lanza made use of another prop that's readily available through a variety of photographic suppliers. The sweep of the chair provided a very good support for the baby's arms. Note that because she was seated with her feet directly out in front of her, the image was shot at about a 40-degree angle to provide a pleasant view. Note, too, how posing her arms and hands on the top of the chair's arms enhanced the composition.

Props are often key to our success, and depending on the personality of our subject, we might choose to add a box to the set, as Kerry Firstenberger did in plate 41. The little person shown here was quite adventurous and wanted to investigate the box, and just before she climbed onto it, we shot the image. We can place several boxes in different combinations in order to draw little people into showing off their climbing skills. Just don't make the arrangement too high in case of a fall.

Below—Plate 39. Photo by Wendy Veugeler.
Top right—Plate 40. Photo by Sam Lanza.
Bottom right—Plate 41. Photo by Kerry Firstenberger.

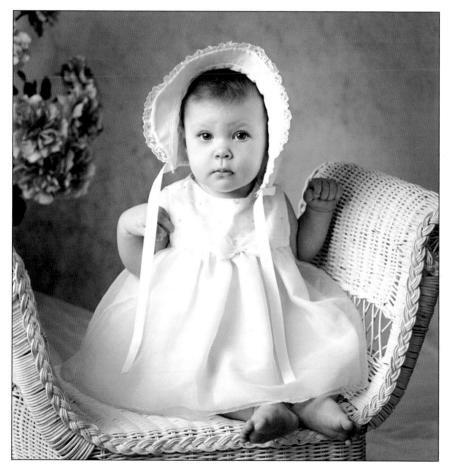

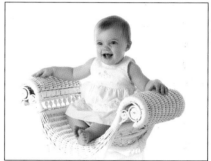

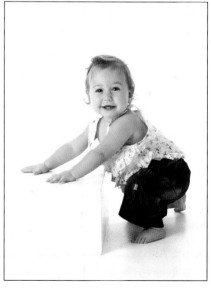

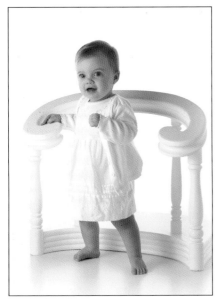

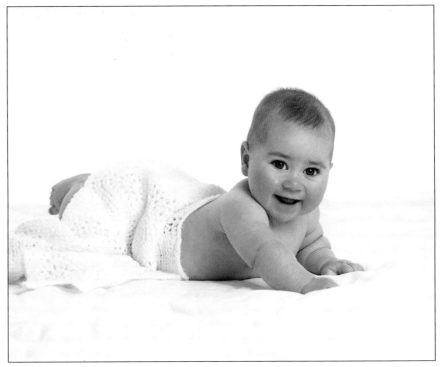

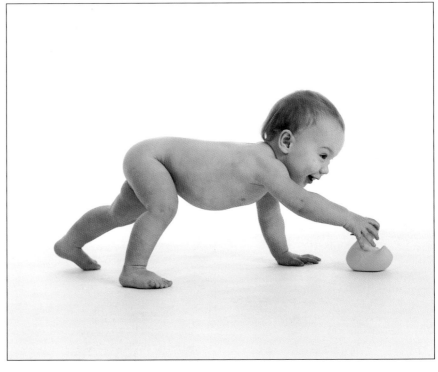

Sam Lanza has many props in his studio that aid him in posing his clients. In plate 42, he used a fence-like prop to aid an infant who needed something to hold on to in order to stand. The baby tested her balance and strength and gained the confidence to stand while grasping the structure with just one hand.

Plate 43 shows a seven- to eight-month-old baby on his tummy. While his lower back and legs were covered with a blanket, we are still able to see his feet. He is a happy and confident little person, and the angle of view—just shy of a profile—makes this a very pleasant portrait.

When they are not standing independently, most babies under one year old will crawl around the set. Plate 44 shows an adventurous little boy after a rubber duck. This is a risky shot in the sense that if he had reversed his feet so that his right leg were farthest behind him we might well have been presented with an undesirable view. Although parents often want their baby photographed in all his or her glory, we need to be cautious. As a general guideline, I recommend that you err on the side of caution and photograph babies nine months old and up modestly. Images made in bad taste do not just reduce sales, but in certain circumstances, they can get you in trouble.

Top left—Plate 42. Photo by Sam Lanza.
Top right—Plate 43. Above—Plate 44.
Photos by Norman Phillips.

Plate 45 shows another crawling baby. The angle of view produces an acceptable portrait.

With the cooperation of your client, you can expand your repertoire with a theme portrait or storybook image. In plate 46, we created a portrait based on the baby's father's profession as an Internet trader. The props were arranged so that it appeared the child was going online. All the props captured the baby's interest so he was less inclined to leave the set. After

*Top—Plate 45. **Bottom**—Plate 46. Photos by Norman Phillips.*

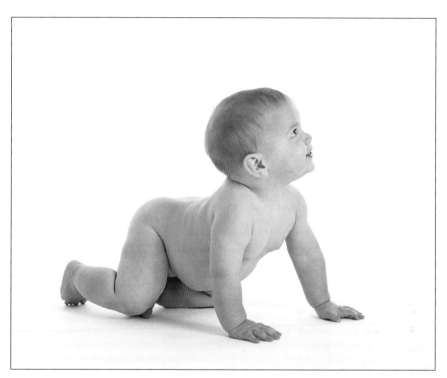

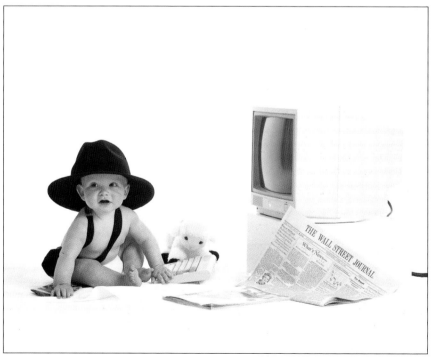

placing him in the set all we had to do was let him get on with it, and the results just flowed.

Plates 47, 48, and 49 show the results of presenting a nine-month-old baby with a very thick law book. With this prop at hand, this little person became very interested in turning the pages, and his actions allowed us to produce a delightful sequence of images.

■ One to Two Years

Children in this age group vary significantly in their abilities, presenting us with challenges that younger clients don't. They are often very mobile, even if they are not yet ready to walk. Between the ages of twelve and twenty-four months, the differences in your clients' abilities and developmental stages will be quite pronounced. As they reach the age of two-and-a-half or three, the difference in their abilities evens out and they tend to have similar reactions to most of our promptings. (Of course, the "terrible twos" stage presents new challenges; we'll cover this in the next section.)

Plates 50 and 51 show a little person who loved to play hide and seek. He was highly mobile, so we needed to find a way to keep him on the set

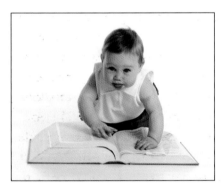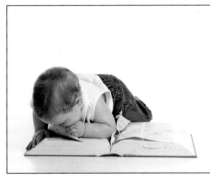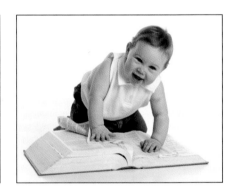

*Left—Plate 47. **Center**—Plate 48. **Right**—Plate 49. Photos by Norman Phillips.*

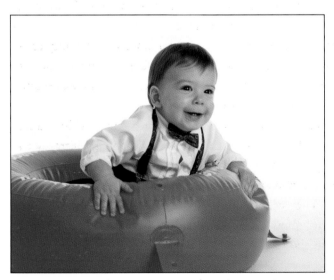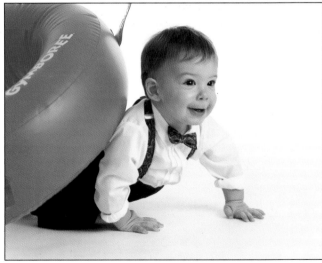

*Left—Plate 50. **Right**—Plate 51. Photos by Norman Phillips.*

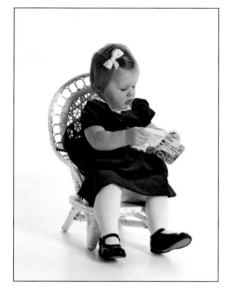 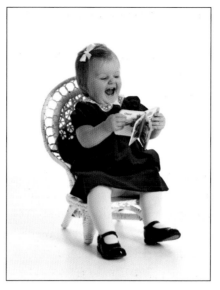 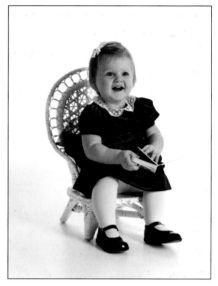

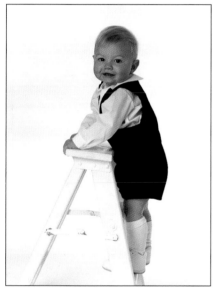

Top left—Plate 52. Center—Plate 53. Right—Plate 54. Above—Plate 55. Photos by Norman Phillips.

for as long as possible. We presented him with a toy tire and positioned him inside it, then invited him to have fun with his mother. This resulted in a sequence of images that represented his personality. Two of the resulting images are shown here.

The client shown in plates 52–54 has been photographed at our studio since she was a few months old. She has shown us on numerous occasions how advanced she is, and this sequence of images shows that when we present a small child with a book he or she will likely stay put long enough to get the desired images. Equipped with a child-size chair and a storybook collection, you have the basis for creating an image your client will enjoy.

In this session, we sat the client on a child's chair and gave her a suitable storybook. Because the child is very bright, she immediately began to act out a fantasy, providing us with the opportunity to create this great trio of images. When trying to re-create this look, choosing an appropriate-size book and chair are important. These chairs are available in sets of two from several suppliers and will prove to be priceless.

We have also found small ladders to be useful in posing very young children. They are available through studio prop suppliers in a wood stain or white finish. You can also buy unfinished ladders in home improvement stores and finish them any way you wish.

To produce the image shown in plate 55, we used a small white ladder to keep this little person busy on the set. Once young clients are introduced to these ladders, they tend to focus their attention on them when they arrive for subsequent portrait sessions—even if it's not an element we plan to use in the session! They will not just climb the ladder, they will perform daring feats just to show how clever they are. The pride this little guy had in his accomplishment shows in the way he took the first step, turned, and smiled at us.

These ladders are also used for posing older children and groups of two, as shown in later chapters.

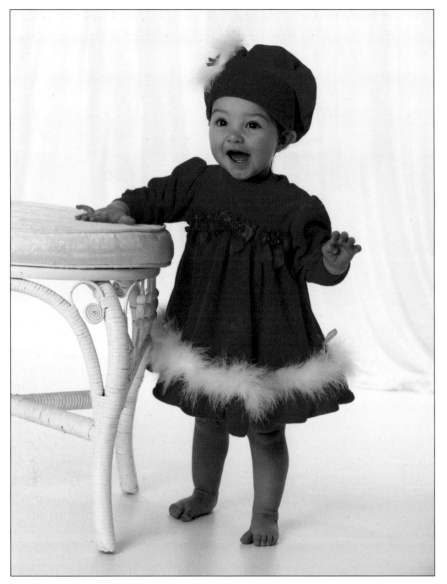

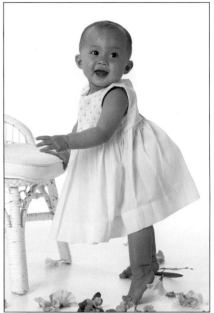

Left—Plate 56. **Top right**—Plate 57. **Bottom right**—Plate 58. *Photos by Norman Phillips.*

Plate 56 shows a girl at age fifteen months with her right hand placed on a chair for support. The height of the chair was important; if we had used a taller chair, she would likely have placed both hands on it and would not have turned toward us. Though the child probably could have stood by herself, the chair helped her feel more sure of herself.

In plate 57, the subject's confidence is evidenced by the fact that she pushed up onto her toes. While she gripped the chair with her right hand, her left was ready to grab the chair if she needed to.

In plate 58, we reverted to our "in the box" routine. This little girl would not stay put anywhere on the set, so after much effort we decided to put her in the box. In most cases this is a last resort, but it is effective.

Small children will generally respond to props that appear to be their size, so child-sized chairs and stools, more often than not, attract them. Far West, Wicker by Design, Pro Studio Supply, and Etcetera are some of the sources for these items. The latter offers classic and more elaborate items.

The seat shown in plate 59 is from Wicker by Design. It is ideal for little girls—the arms are just right for their little hands, and it allows us to pose them showing their pretty dresses.

The shown bench in plate 60 is probably the most popular prop in our studio. We observe the various approaches the children take to position themselves on the seat, and this results in a varied selection of poses—from back views, to side views, to poses like the one shown here—that just happen without our intervention. The same bench is used in the portrait shown in plate 61, and you can see that this child took a different approach to it.

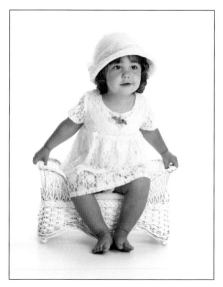

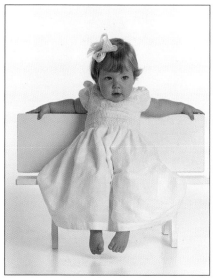

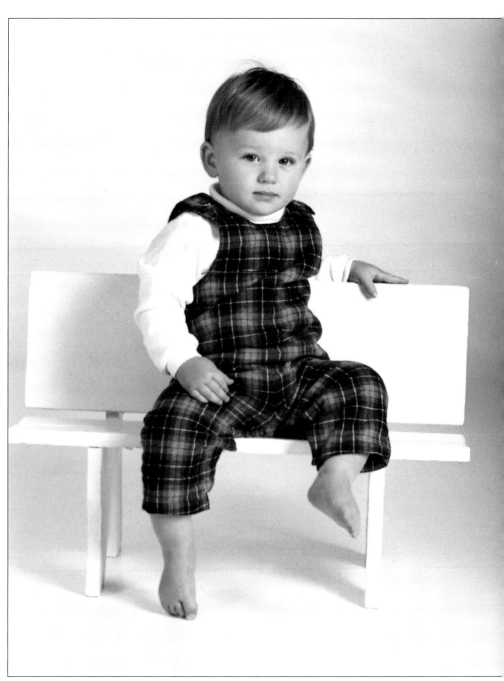

Top left—Plate 59. **Right**—*Plate 60.* **Bottom left**—*Plate 61. Photos by Norman Phillips.*

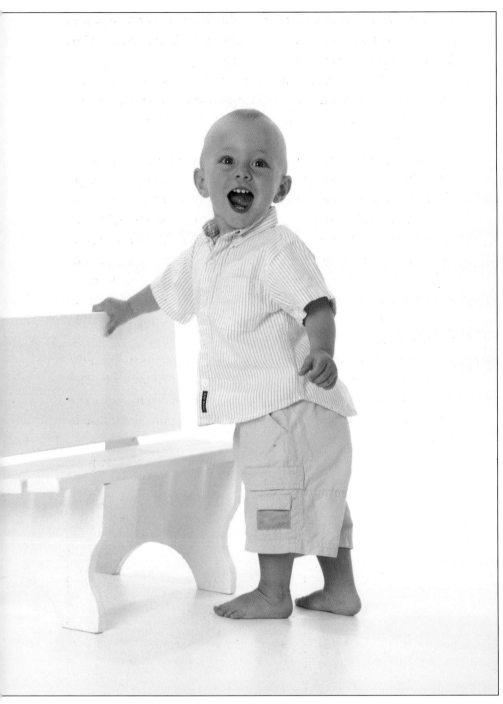

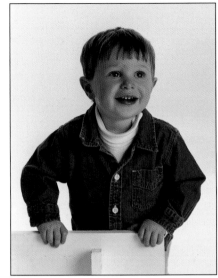

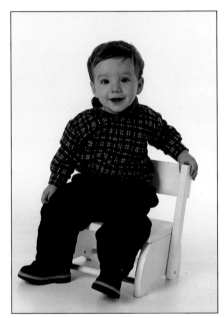

Left—Plate 62. **Top right**—Plate 63.
Bottom right—Plate 64. *Photos by Norman
Phillips.*

Not every child wants to sit on the bench, but they will readily use it as a support as shown in plate 62. Those who can walk with support will often walk around the bench, and that enables us to obtain different expressions and poses, either walking or peering over the back of the bench as shown in plate 63.

Little white seats are also very useful for toddlers. The one shown in plate 64 is sold in pairs, and having two is often helpful when posing two tots of approximately the same size. Note the angle at which the seat is set in this image. It is approximately 45 degrees off camera so we do not get

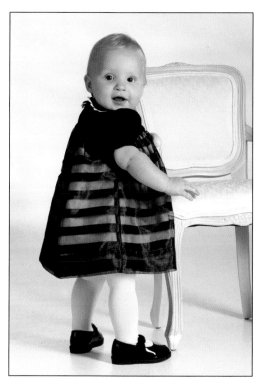

Plate 65. Photo by Norman Phillips.

too much of a frontal view of the child. When the child is placed square to the plane of the camera we will get a relatively boring view. The three-quarter pose is much more pleasing.

In plate 65, we have the girl positioned by a chair that's just the right height for this little person. She was placed this way so that she had to turn in order to see us, which allowed us to create a different style of pose.

Between the ages of twelve and fifteen months, many subjects—especially boys—are drawn to climb, be it on a ladder, an arrangement of boxes, or a posing bench, as shown in plate 66. The look of delight at his achievement in climbing on this bench is written all over this little guy's face. Any time we can get a child at such a young age to perform without us having to Velcro them down is a bonus.

This particular prop can be used in three different positions—on its end, in reverse, and as is shown here. There are number of these on the market. This particular one was purchased from the Harrington Prop Company.

To produce the image shown in plate 67, we placed an object the child was interested in on top of a box and had him go for it. This technique works nine times out of ten when we would otherwise have difficulty in keeping the child in place. The process results in some very nice portraits.

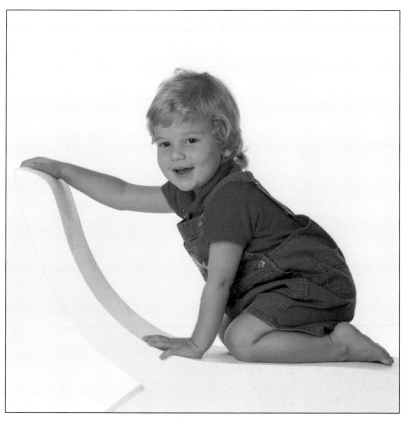

Plate 66. Photo by Norman Phillips.

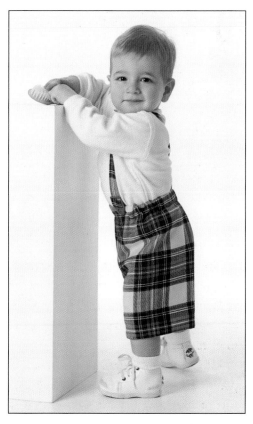

Plate 67. Photo by Norman Phillips.

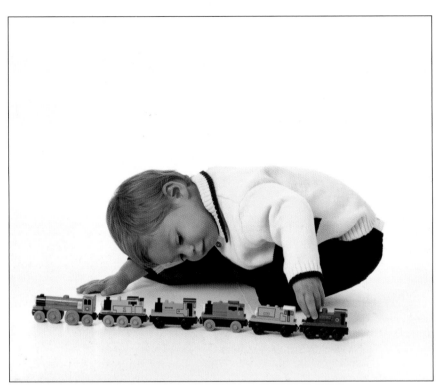

Left—Plate 68. **Below**—Plate 69. Photos by Norman Phillips.

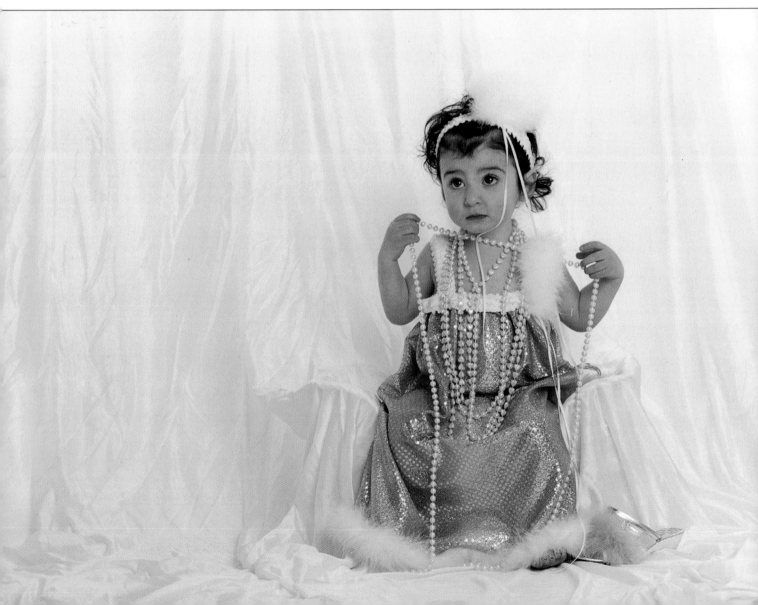

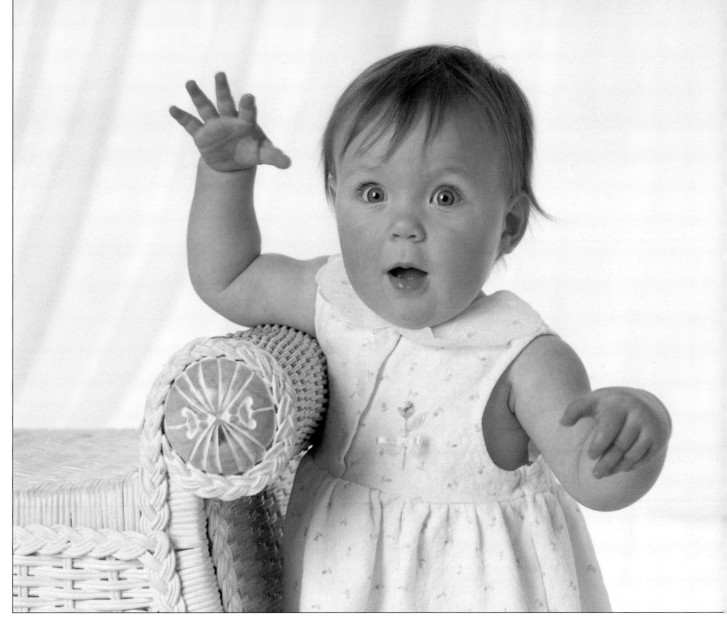

Plate 70. Photo by Norman Phillips.

To occupy the subject shown in plate 68, we once again provided an object of special interest to the child. In this case, his mother brought in his favorite train set. We obtained numerous images of the child, who was totally captivated by the train. It is usually best to have a parent bring one of their child's special playthings to the session. When we provide the props, the children often think we have presented them with a gift. That can result in some very disappointed toddlers, and they will let us know how they feel in no uncertain terms.

In plate 69, we again used the pretty wicker seat shown in plate 66. This time, however, we draped a satin fabric behind the girl and brought it over the seat to create a softer, more delicate look. Boas were used to add to the effect of the feminine pearls, which she held in her hands. This time, because we had her mother positioned to the left of the camera to attract her attention, positioning the girl square to the camera worked quite well.

In plate 70, we positioned the toddler close to the wicker seat so she could lean against it. In this portrait she experimented with her ability to

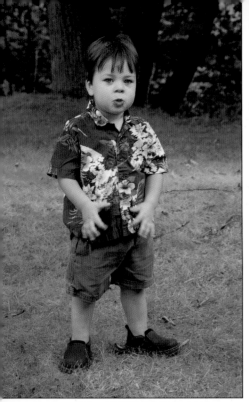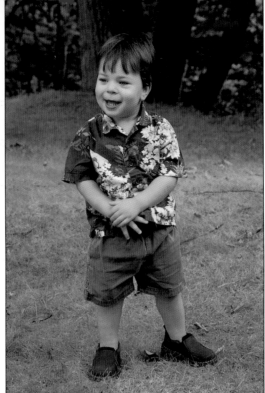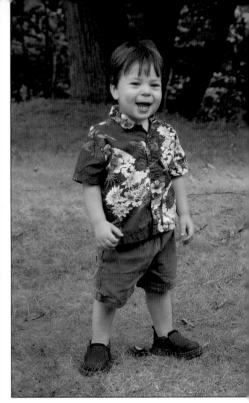

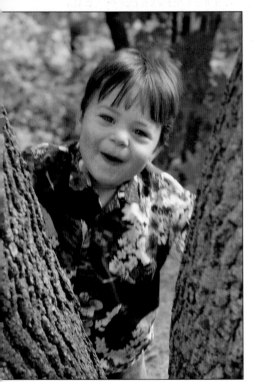

Top left—Plate 71. **Center—***Plate 72.* **Top right—***Plate 73.* **Bottom left—***Plate 74. Photos by Norman Phillips.*

stand without help by raising her arms, though we cheated a little by placing her upper arm on the arm of the seat.

When outdoors, communicating with little people is more difficult because our voices do not carry so well as when we are indoors. Additionally, when outdoors, children are drawn into their surroundings, so getting them to stay in one place is more difficult than in the camera room.

If we turn the portrait session into a game, we will have more success. The little guy pictured in plates 71, 72, and 73 liked to blow out his chest and make his presence known. We decided that the best approach to creating good images during the session was to engage him in a little game. First, we let him run about a while, then we encouraged him to do his thing by having his mother huff and puff like he would. He performed as planned. After he huffed and puffed, he showed us how proud he was, and the expressions just flowed. As soon as this little performance was over, he was off and running again.

An even better way to get children of this age to "pose" is to play peek-aboo. Outdoors, a tree is always a good prop, and a fork in a tree is perfect as shown in plate 74.

■ Two to Four Years

Now we are truly into the realm of the dreaded "terrible twos." While younger subjects can be difficult and willful, during this age we get to see the ability of some toddlers to vex parents and drive photographers around the bend. We are always required to have patience when working with children, but now our nerves and our tolerance for the tantrum will be tested.

Despite the potential for the camera room to become a psychological testing laboratory, this is the age when we may have a lot more fun and creative satisfaction. Often we will discover that these little people are much brighter and more understanding than we anticipated, and we should never prejudge what a child is capable of.

Once our clients reach two years of age, many have the ability to remember words and repeat them, and we can capitalize on this ability. Additionally, if we are skilled at communicating with these kids in an age-appropriate manner, we have the chance to create some delightful images.

When we want a child at this age to stand in place we need to use some form of persuasion or demonstration. Karen Rodgers places a penny on the spot she wants the child to stand and invites the child to stand on it. This is what she did to obtain the image shown in plate 75.

Placing my index finger on the floor where I want the child to stand works very well. That is what I did to get my subject to stand where he is pictured in plate 76. When working with the younger subjects in this age group, I often ask them to pretend their feet are stuck and they cannot move; this also works well.

Left—Plate 75. Photo by Karen Rodgers.
Right—Plate 76. Photo by Norman Phillips.

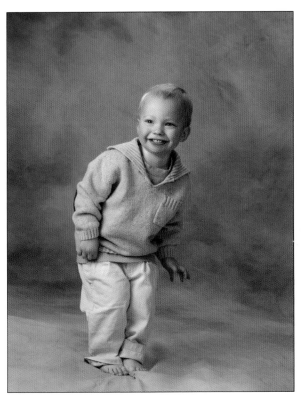

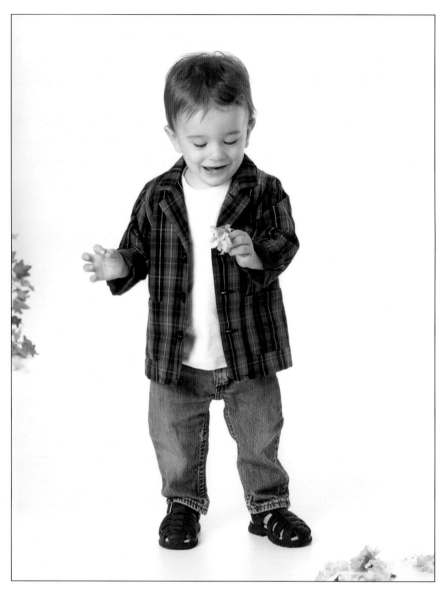

Plate 77. Photo by Norman Phillips.

Another technique is to give them something to hold on to that occupies their hands and arms so they do not let their feet take over their motor. The more we work with these young children, the better we can encourage them to do what we need them to do.

Plate 77 shows another toddler on our set occupied with petals from a basket. His curiosity is obvious, and he is happy doing what he is doing. The portrait is but one of many from the session. Some will say that the image is not as saleable as it might be because he was not looking at the camera, but with small children we are likely to get as many candid portraits as formal ones, and the mix offers parents many choices and encourages larger sales.

There are those who say we should not use flowers in portraits of boys, but I disagree. Flowers are an important part of our environment, and boys should not be discouraged from showing an interest in them. Perhaps it is how the flowers are employed in the session that really matters.

Plates 78 and 79 show a girl having fun with a basket of flower petals. We usually tip the petals out of the basket and encourage the child to put them back in. Often they become so involved with the process we have to work hard to get them out of it. During the session we obtain a series of different views and delightful expressions.

Flower petals played their part in plates 80 and 81, but the scenario in this sequence was a little different. Though the girl in the portrait had very busy feet, the basket and petals kept her close to where we wanted her.

Top left—Plate 78. Top right—Plate 79. Bottom left—Plate 80. Bottom right—Plate 81. Photos by Norman Phillips.

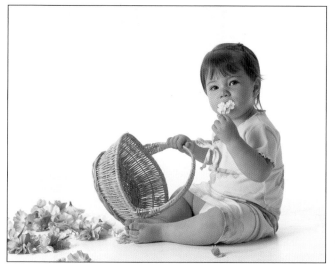
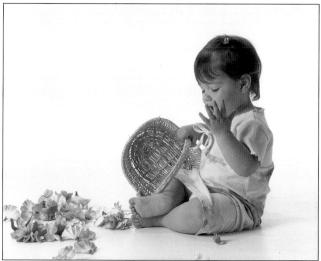

Plate 82 shows yet another toddler photographed with flower petals and a basket. The little girl showed us that she was into the petals—both in and out of the basket. The flowers and basket are a perfect complement to her attire.

To photograph the subject shown in plate 83, we set up an array of white teddy bears and a white stuffed rabbit in an effort to capture the interest of a little person who would otherwise have preferred to wander around the set. As you can see, our mission was a success.

In plate 84, Kerry Firstenberger placed petals on a box to attract the

Top—Plate 82. **Below—***Plate 83. Photos by Norman Phillips.* **Facing page—***Plate 84. Photo by Kerry Firstenberger.*

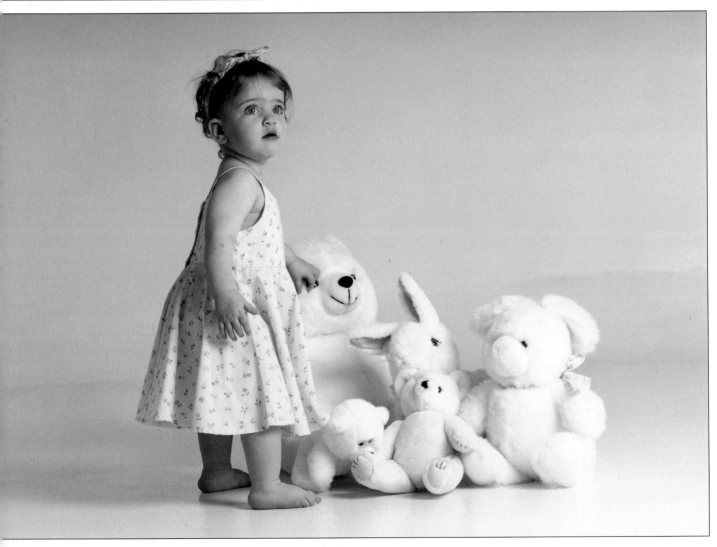

Left—Plate 85. **Bottom left—***Plate 86.* **Bottom right—***Plate 87. Photos by Karen Rodgers.*

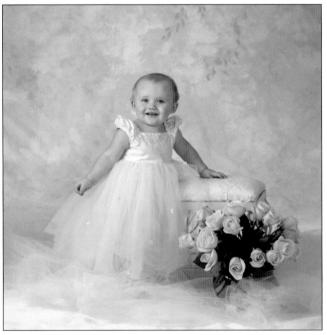

child. Note how the little subject communicated her interest. The angle of the box ensured that when she turned toward the camera, our view of her would be pleasant.

Placing a child in a full profile pose can produce attractive images as shown in plate 85, a portrait by Karen Rodgers. Karen employed a small pillar as a prop, and the child was placed so she could rest her hands on it to help her hold her position. The pillars are available from various suppliers.

Plate 86 shows another portrait made by Karen Rodgers. Karen employed a padded stool as a prop and had the child rest her arm on the soft fabric; she actually leaned on it, which helped to personalize the pose.

In plate 87, Karen used the same prop, turned in a different direction, and had the child stand with just her hand resting on the stool.

In plate 88, Karen's subject was positioned with her body in profile to the camera but with her head turned back toward the camera. We cannot see the prop the child rested her right hand upon as it is nicely shielded by the toddler's body. This is a nice innovation.

Plate 88. Photo by Karen Rodgers.

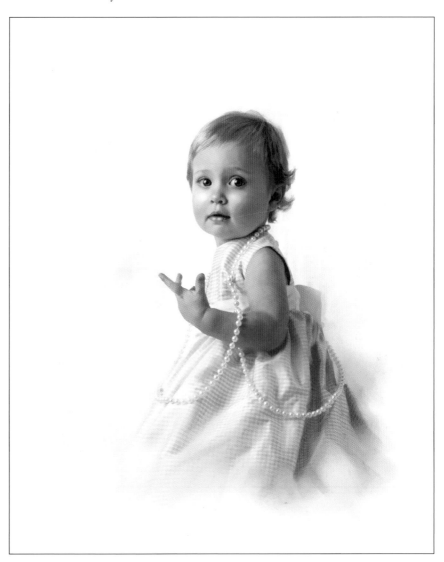

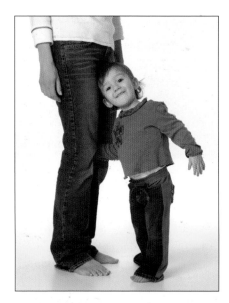

Using a parent's legs as a prop can be very effective, especially when a child is a little reluctant to let go of the parent. Kerry Firstenberger photographed a child holding on to mother's leg, producing the image shown in plate 89. Using this technique can result in all sorts of attractive portraits. Sometimes we will get images with the child hugging a parent's leg, and sometimes even both legs. Occasionally a child will hide between the legs and pop out as in a game of peekaboo.

Top—Plate 89. Photo by Kerry Firstenberger.
Bottom—Plate 90. Photo by Wendy Veugeler.

Plate 90, a portrait by Wendy Veugeler, uses a tricycle as a prop. While she managed to capture the image with the child standing in front of it, it is likely that at some point during the session, the child had some contact with the prop.

In the portraits shown in plates 91 and 92, Julia Stotlar used a couch as a base and prop. In plate 91, she had the little person seated in profile to the camera. A couch is a safe place for a child as it is something he or she

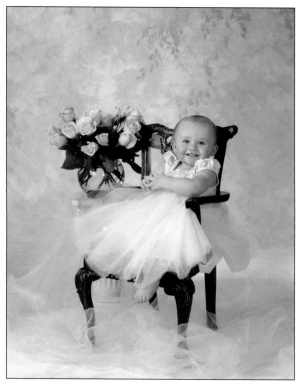

Left—Plate 93. Photo by Joanne Alice.

Right—Plate 94. Photo by Karen Rodgers.

will be familiar with. If you have one in your camera room, it will prove very useful. At this point of the session, the child was more interested in his feet than in what was going on at the camera position. In plate 92, Julia simply placed the child on the couch and let the pose unfold.

Generally, it is not recommended that a subject's feet be aimed at the camera as this normally causes them to appear larger than they are. However, by being selective with our exposures we can capture portraits that genuinely represent the subject as Julia Stotlar did in this example. It is the child's body language that makes this portrait work.

Plate 93 shows the little climber mentioned earlier. Joanne Alice provided this little guy with this box on which to climb, and he showed a great sense of delight at having made the ascent. The trick in producing a portrait like this is to use a box that is about waist high to the child. This gives the adventurer enough leverage to pull himself or herself up onto the box. This exercise might create a nerve-racking moment or two, but mother will know if the pose is likely to work and will decide if it is allowed. If this is a first-time event for the child, everyone in the camera room will need to be in a rescue mode.

Plate 94 shows a portrait by Karen Rodgers. She seated the child in an armchair, which most often does not produce the best portraits because unless the child curls his or her legs, the feet stick out in front of them. Since the girl in this image is dressed in a full skirt and we see only one foot, the portrait is adorable, even if the pose is not perfect.

Plate 95 shows a little person seated on a white stool that was positioned 40 degrees off camera to prevent a square-on presentation to the camera.

Note the angle of his feet as they relate to us. The result is much better than it would have been if we had him facing us with both feet in a straight line across the camera plane.

We are sometimes privileged to photograph the most charming of children, and plate 96 shows one of these delightful little people. In this portrait we once again employed the little wicker seat. The little girl was an ideal candidate for this prop. She was calm and charming and had a lovely smile. Her full-length dress added to the mood of this delightful image.

The point here is that we should base our prop selections on the maturity and personality of our subjects. We need to avoid the temptation to encourage a child to do something he or she is not yet ready to do. Nevertheless, there are times when we are in a position to capture a child doing something for the first time, which is memorable for the parent.

Karen Rodgers exercised this kind of good judgment when she created the portrait shown in plate 97. Placing a child on a chair in this manner at the age of eighteen months should be done only with the consent of the parent. As adventurous as little people of this age may be, there is always the risk of a fall because children are impulsive and not aware of the dangers of their actions. But in this portrait, the child appears to be comfortable, though of course we do not know how long he stayed in this pose.

Note the angle of the chair and the child. The boy is posed in three-quarter presentation that allows us to see all of his pleasing characteristics.

*Top left—Plate 95. **Bottom left**—Plate 96. Photos by Norman Phillips. **Bottom right**—Plate 97. Photo by Karen Rodgers.*

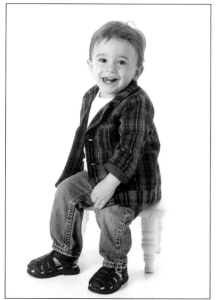

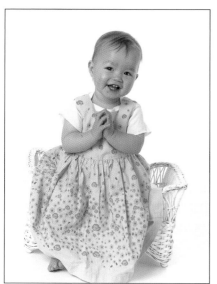

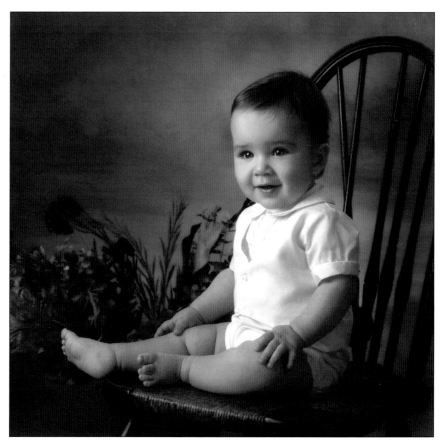

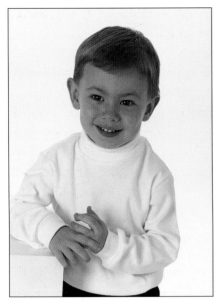

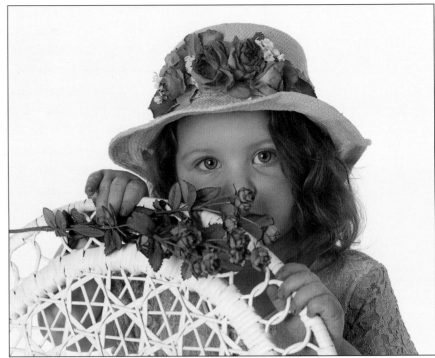

In this pose the child could easily look in any direction Karen wished so she could obtain images that featured a variety of expressions and head angles.

Plate 98 shows a portrait in which we again employed a box for the subject to rest his elbow upon. This tactic is constantly employed when photographing children this age. For this portrait, we positioned the boy at the box and placed his right arm on it. We positioned his left hand on top of his wrist to achieve a nice arrangement of his hands and arms. At about two-and-a-half years of age, many children will respond to our coaching and keep their hands close to where we positioned them. We often tell our young client he is posed like his dad, or a big guy. This gives him confidence. It cannot be overstressed that even if a child does not fully understand our words, the tone we use will communicate our caring.

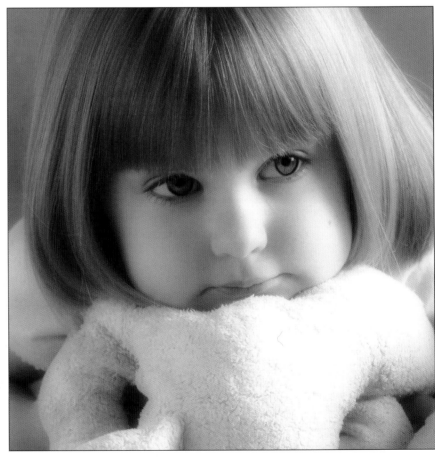

To produce the image shown in plate 99, we employed a wicker-back chair and positioned the girl behind it. Next, we arranged her hands on the chair back to control her position, and we invited her to peek over the top.

*Top left—Plate 98. **Top right**—Plate 99. Photos by Norman Phillips. **Bottom right**—Plate 100. Photo by Julia Stotlar.*

Having her hold a sprig of flowers and wear a hat helped us to produce a portrait that is a little different from the norm.

The chair, though child sized, was just a little high for the client. Though we originally had her posed a little toward our right so that we would see her more clearly, she moved a little to our left.

In plate 100, Julia Stotlar used a very simple but effective technique to obtain a beautiful portrait. The simplicity is something that is too often passed over as photographers attempt to get different, more creative poses. Julia simply sat the child down and gave her what was probably her favorite stuffed toy, the kind that some little people take everywhere they go. The girl did what she usually did: she tucked it under her chin and presented us with the opportunity to capture this lovely image.

While we are brainstorming on how to pose children, we may well fail to recognize the natural tendency of our young subjects to present us with poses of their own creation. Unless we are in the fast-moving studio business where time is of the essence, we should allow time for children to do their own thing. Often all we need to do is set the stage, and the poses will present themselves.

The next several examples focus on location portraits, both indoors and outdoors. In the black & white portrait shown in plate 101, the boy knelt in a reverse position on a chair so he could rest his hands on the back of the chair and engage us with a very sweet expression.

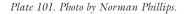
Plate 101. Photo by Norman Phillips.

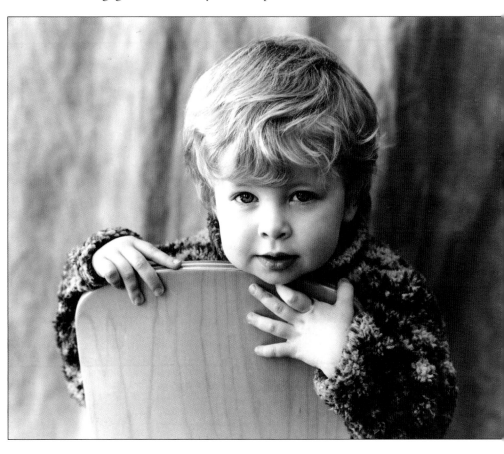

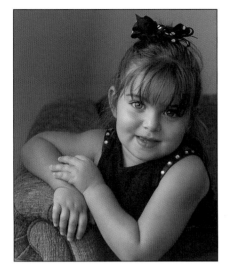

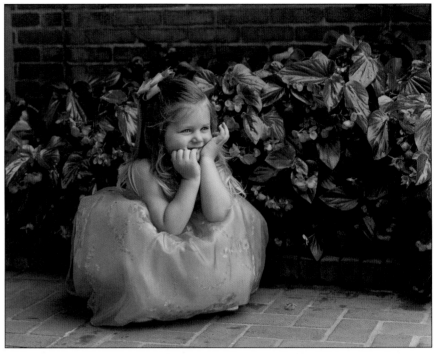

Little people are often very comfortable on their knees. If you observe small children on a daily basis, you will see them kneeling while they play. Therefore, a kneeling pose is a natural choice for posing children. In some cases we may wish to move a hand or arm, but the basic pose will be good for several exposures. This position can also be used as the basis for a profiled body pose by turning the chair sideways to the camera and having the subject turn his head toward the camera.

When creating images in a private residence, we will generally work with props available in the client's home. In plate 102, I had the little girl seated at the right end of the couch so she could place her arm on the armrest. I then brought her left hand to rest on her right forearm. The pose is delightfully childlike because her resting arm is slightly raised, which caused her to tilt slightly to our right. We then simply engaged her in an appropriate dialogue and captured the image.

The girl in plate 103 was photographed in the midst of a garden. For a child of this age a locale like this can be almost overwhelming—but exciting. Once she was positioned where we wanted her in the scene, she examined the flowers and expressed her fascination, and we simply changed our angle to create different expressions and compositions. In this portrait, she sank down and demonstrated pleasure with her surroundings. Capturing a pose like this is one of our objectives in such a session.

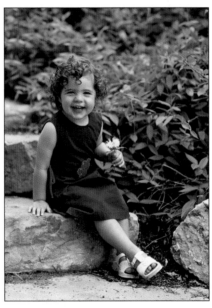

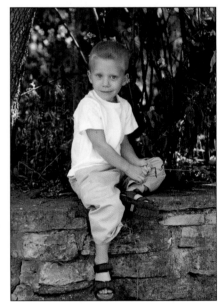

Top left—Plate 102. Top right—Plate 103. Bottom left—Plate 104. Bottom right— Plate 105. Photos by Norman Phillips.

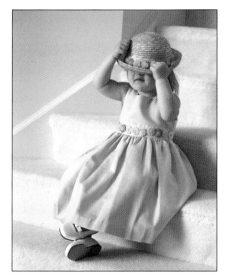

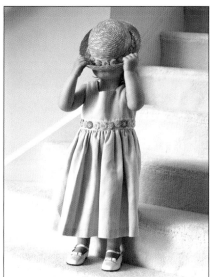

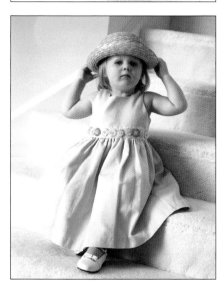

To create the image shown in plate 104, we took advantage of the steps in a garden. The child was seated on the bottom step with her right hand, placed slightly forward of her torso to draw her slightly toward the camera, taking some of her weight. The flower in her hand helped add to the mood and style of the portrait and, as a final touch, we had her cross her ankles. This produced the desired tapered line from her knees to her feet.

When photographing kids about two-and-a-half years old and up, we can begin the process of separating the boys from the girls. In plate 105, we had the boy bring his left foot to the level of his seated position; this is more of a boy's pose than a girl's. His hands were then brought over to his raised leg. The pose has style and motion and creates a three-quarter view. This pose is perfectly suited to this person's personality.

In plates 106, 107, and 108, we see a sequence of images of a little girl seated on—and standing near—the bottom stair in the entrance to her home. Note how the angle of view allowed us to get attractive poses as she wrestled with the hat we placed on her head. Using a hat tends to lock the child in roughly the location where we place them since, as in this sequence, they are often just engaged in having fun with it.

In plate 109, we photographed the same child on the next step up, but this time we had her interact with the family dog. We arranged to have the dog on the same step and the child plucking petals from a rose and offering one to the dog. In addition to adding interest to the image, this kind of interaction can help to keep the child in one place. In this case, positioning the subjects on a single step ensured that they would stay the same distance from the camera for each of the exposures.

Top left—Plate 106. **Center**—Plate 107.
Above—Plate 108. **Right**—Plate 109.
Photos by Norman Phillips.

■ Twins and Triplets

Though the last chapter in this book pertains to photographing groups, at this age, special techniques are used to create images of multiple subjects. Therefore, we'll briefly discuss the topic here, as well as in chapter 4.

Plate 110 shows twins positioned side by side in a seated position. Because the babies were unable to sit without support, we positioned them with their backs against fabric-covered boxes. This setup will work as long

*Top left—Plate 110. **Top right**—Plate 111. Photos by Norman Phillips. **Bottom left**— Plate 112. Photo by Cindy Romano.*

Plate 113. Photo by Kerry Firstenberger.

as the babies are reasonably strong and not likely to topple (still, it is a good idea to use fabrics to build a softer, more comfortable set). These little subjects may slide down and become little heaps of delight, so we may have to reset them several times before the session is over.

Plate 111 shows babies aged six to seven months seated on the floor, one behind the other and profile to the camera. This pose is sometimes referred to as the "train." We can create this pose with any number of babies if they are able to sit without support. If they cannot, we may have to endure a bit of chaos, with infants falling in different directions. Needless to say, this would likely result in some unhappy little people. Keep in mind that often, when a baby falls backward and bumps his head, there will be a lot of tears—not necessarily because they are hurt, but because they have been shocked into a tearful reaction.

Fortunately, in this situation, the babies were able to maintain their pose and, once positioned, immediately became quite animated, creating some interesting image options.

In plate 112, Cindy Romano swathed a grouping of triplets in soft, white towels. Note that the babies are not positioned too close together; it is important to allow some room for each baby to move around, as sometimes they will, even at this early stage of their development. This posing concept works with individual babies or twins and can be used for up to six babies, so if you get the opportunity to photograph sextuplets, you will know where to begin. Your creativity will then take over.

In plate 113, you'll see another posing concept that employs a basket. Kerry Firstenberger placed the two babies so that their heads are at opposite ends to allow them to take up less space across the width of the basket. In doing so, a second objective was achieved: their positions prevented them from entangling their arms and obscuring their faces, which can readily happen as they wriggle around (in fact, you can see that these subjects have stretched their arms in this portrait). This technique will work as a floor pose too, so you are not committed to using the basket.

When creating a portrait like this one, the camera must be positioned directly above the basket; otherwise, there may be a distortion in the perspective. For this reason, it is a good idea to have a small ladder on hand.

2. Children

As children grow into their fourth and fifth year they become more aware of their limbs and what they do. They are also better able to respond to direction and, as a result, we can create images that are better composed. When working with the younger children in this age group, however, we may find that our subjects' attention spans are relatively short. In order to maintain the composition and the pose we desire, we may need to reposition our clients and check the composition with each exposure.

■ Girls versus Boys: Some Observations

At about the age of four, many boys and girls begin to identify strongly with others of their gender (though for some this takes a little longer). For instance, some boys will respond negatively to flowers, and some girls will

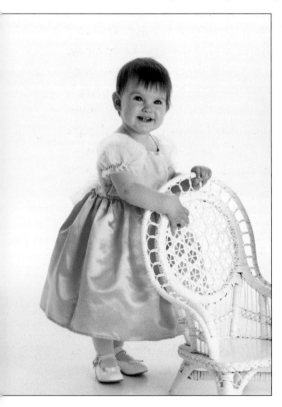

steer clear of playing with trucks. While some kids this age couldn't care less about the issue, we need to be sensitive to the parent's attitude when selecting "gender specific" props. Often, the parent will react negatively if we seek to pose the child with a prop or on a set that they do not deem gender appropriate. Of course, we can also choose from an array of props that work equally well with boys and girls.

In the next section, we will look at individual portraits, and when discussing a pose used for a boy, I will explain (where applicable) how the pose can be adapted to work with a female, and vice versa. Later, we will look at poses that are more explicitly feminine or masculine.

Plate 114. Photo by Norman Phillips.

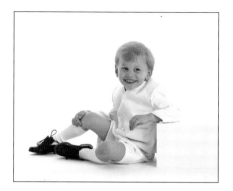

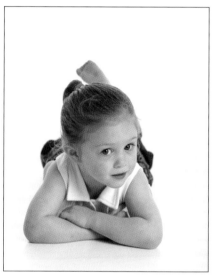

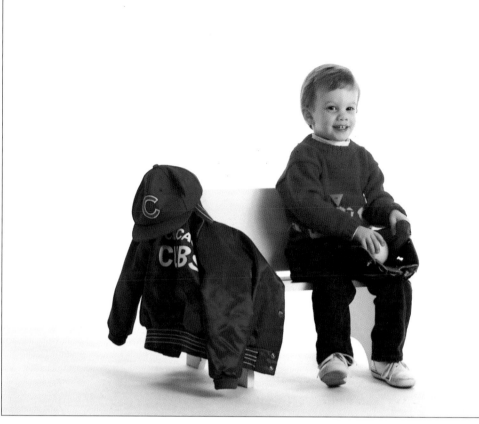

■ Boys and Girls Four to Five Years

The subject in plate 114 was posed in profile behind a wicker chair. She looks delightfully feminine, and the pose and prop are a good fit. The decorative aspects of the chair make the set better suited to a female than a male, though with a more masculine prop, the pose could work for a boy.

Plate 115 shows a boy seated on the floor with his elbow on a box. Note that there is a nice, tapered shape from his knees to his feet. While there is nothing feminine about this pose—the subject is very boyish—we could also use it with a girl if she were wearing a dress or decorated jeans, though we might select a more feminine prop or place a drape over the box to make it appear more feminine. This pose could be somewhat difficult with a younger subject, as a younger child may not hold this position for more than a few seconds.

In plate 116, the subject was posed on her tummy with her arms folded in front of her. We could use the same pose for a boy. She has her feet up behind her head, but because she is barefoot it is okay. If she were wearing shoes, they might have blended with her hair color—especially if the shoes were a dark shade.

In plate 117, we have a boy seated at the far end of a small white bench, with his baseball jacket and cap hung on the other end of the bench. He was posed holding his mitt, with the ball tucked inside it. This locked him in position on the set.

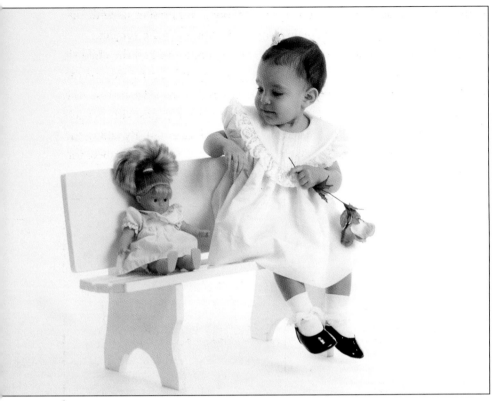

The same bench was employed in plate 118. To create a storytelling portrait, we involved the child, who was placed at one end of the bench, in playing with her doll, which was placed at the other end. The child's focus on the doll kept her on the bench for a period of time, which enabled us to capture numerous images.

To create the portrait shown in plate 119, we seated the little girl in profile to the camera on a stool that allowed her feet to comfortably touch the floor. We drew her attention to our right to produce this lovely profile image.

We amused the child with some off-camera humor to elicit the reaction shown in plate 120. The height of the stool allowed the child to tip her upper legs slightly downward and to place her feet on the floor. (To recreate this with your own client, make sure that the seat is about two inches higher than the length of her lower leg.) Note that the girl in this image is holding an object in both hands. The use of an object for a child to hold, and working with a seat that is well suited to the size of the child, helps to curb the movements of both hands and feet that are quite natural at this age.

Rocking chairs are always attractive to small children, and we used one in plate 121. The girl was comfortable and confident in this seat, and the position of her hands on the arms makes the portrait pleasant, but if her ankles were crossed, left foot over right, the portrait would be improved.

Plate 122 shows the same girl engrossed with a balloon we had given her. Placing a second balloon on the seat of the chair kept the girl in the

Left—Plate 118. **Top right**—*Plate 119. Above—Plate 120. Photos by Norman Phillips.*

desired area. In such a case, moving the balloons can present us with different views as long as we maintain communication with the subject.

In plate 123, we employed a book as the key prop. We had the child sit on the floor with her bottom positioned just beyond the far side of the book and asked her to extend her legs to our right. In order to turn the pages, she had to rest on her right hand and turn the pages with her left hand (at a young age, most children are fairly ambidextrous). By taking the picture with the camera a little to the left of the center of the composition we were able to present a nicely composed portrait.

Top left—Plate 121. **Top right***—Plate 122.* **Bottom***—Plate 123. Photos by Norman Phillips.*

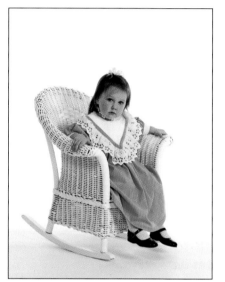
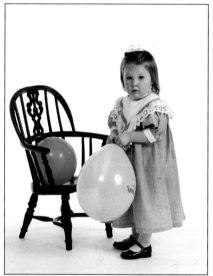

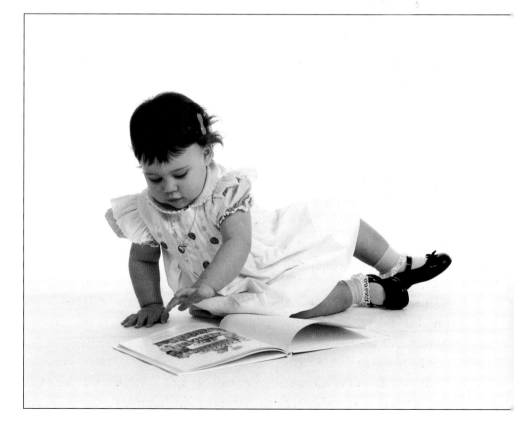

Small children enjoy interacting with their parents and with us in the camera room. To create the portrait in plate 124, we had the child stand in the desired position in the set and asked him, "How tall is the ceiling?" We

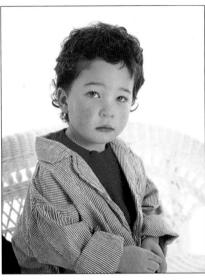

Top left—*Plate 124* **Top right**—*Plate 125.*
Bottom—*Plate 126. Photos by Norman Phillips.*

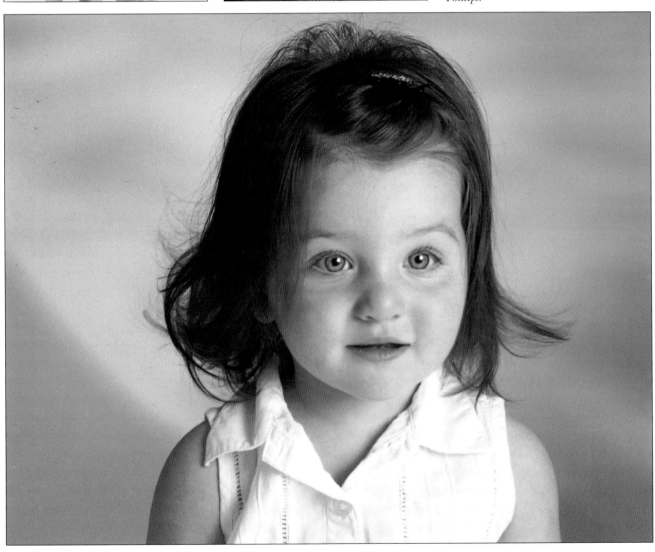

Plate 127. Photo by Norman Phillips.

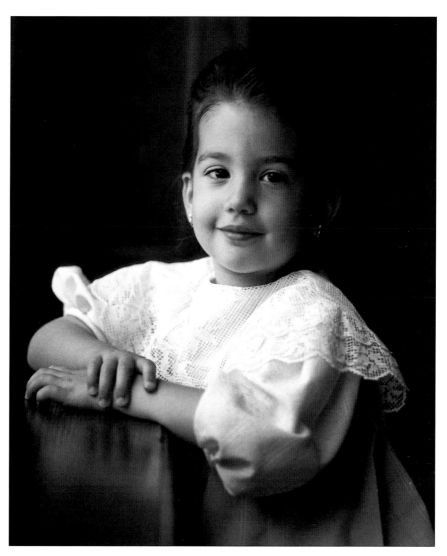

might also have asked him to show us how tall he is, and thrown our own arms upward for him to copy.

In plate 125, the boy was posed in a seated position at a slight angle to the camera. Note that we have, once again, brought our subject's hands together to hold on to an object we provided. We then engaged him in conversation, and he turned toward us with the expression shown here.

In plate 126, we broke one of our own rules by posing the child square to the camera. Movement of the hands or feet can easily affect the overall pose. Therefore, though only the head and shoulders show in this image, we used a small toy to occupy the client's hands and chose a seat with a height that allowed the girl to place her feet firmly on the floor. By telling silly stories and making strange sounds, we were able to elicit the desired expression.

Plate 127, a window-light portrait, shows the child with her arms resting on a window sill. You will note that we had her place her right hand over her left wrist. After posing her hands in this way, we told her it was so her arms would not move until we had taken the photographs. At this age

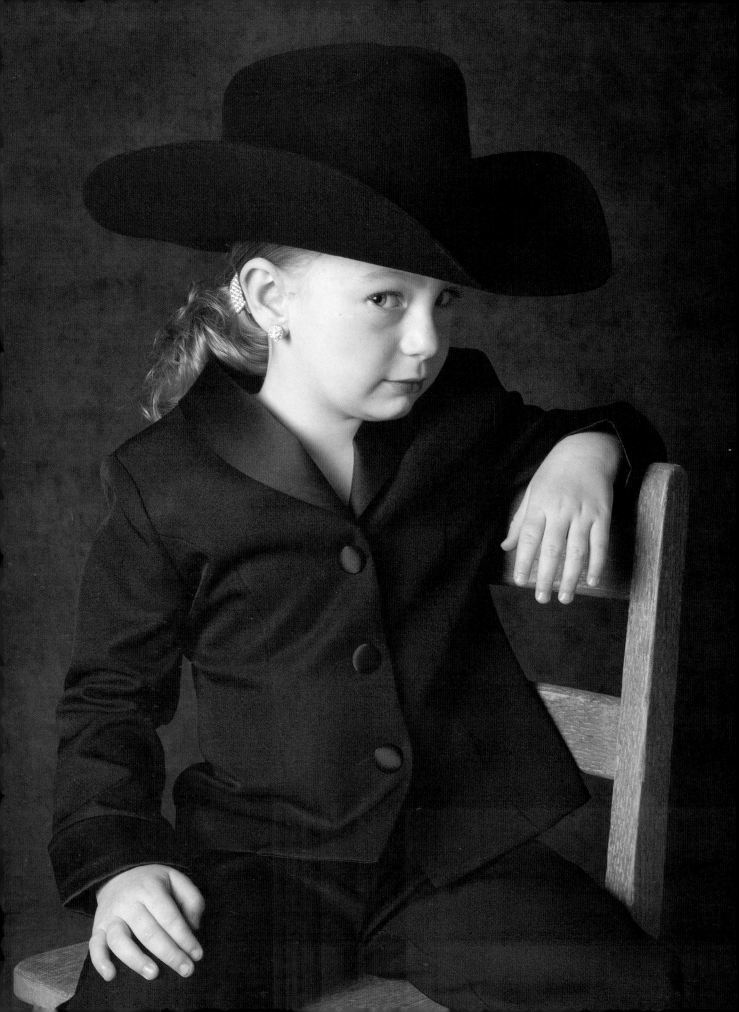

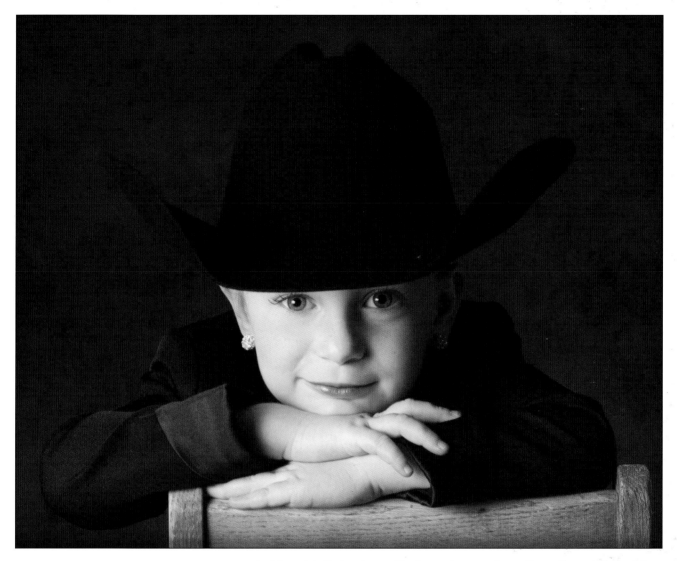

Facing page—Plate 128. Above—Plate 129.
Photos by Kerry Firstenberger.

and older, this little piece of information works really well, and the subject will not move her hands until you are ready to re-pose her.

While feminine poses aren't considered appropriate for boys, there are masculine poses that work well for females. This point is beautifully illustrated in plate 128, which shows one of my favorite portraits created by Kerry Firstenberger. The girl has style and lots of attitude, and the pose shows it to the fullest. Dressed in a cowboy hat and a matching suit, she is posed perfectly for who she is. By posing her with her head turned to our right, Kerry heightened the attitude that was largely created by having the subject rest her left arm nonchalantly on the chair back. While we may often rely on poses that are routine and generally acceptable, we may sometimes wish to create a portrait with a pose that is distinctly personal.

Plate 129 is another portrait of the same child, and again the girl's personality exudes from the image. In this portrait, Kerry used the back of the same chair as the prop and had the girl rest her arms on the top of the chair. The hat, suit, and the back of the chair are harmonious and add to the strength of the image.

Plate 130 shows a child posed in a similar style. Kerry had the girl place her right arm on the top of the chair. She then placed her left hand on top of the other with the fingers of the left hand spread to provide a nice view of the fingers. If the fingers were closed, we would be presented with too solid a view of the arm and hand. The height of the chair's back was well suited to the child; she was able to easily rest her chin on her top arm.

This pose would likely be more difficult for a younger child to hold because the width of the top of the chair does not offer much of a base on which to rest. The prop worked well for this child, however; she is obviously mature for her age. Though Kerry used this particular chair to good effect, there are numerous other props that could be used with this type of pose. Tabletops, posing benches, boxes, and other objects of suitable height and surface can be just as effective.

Plate 131 shows another portrait of the child pictured in plate 130. While the same prop was used, the mood in the image is different. Note that Kerry had the girl seated near the edge of the chair so her posture is upright and she appears quite alert. We need to avoid having our little subjects seated all the way back in the chair where they are likely to relax and settle into a loose pose. When seated closer to the front edge of the chair, the child's feet will rest comfortably on the floor, and he or she will be more likely to sit up straight and tall.

Plate 132 shows the ideal place for the little person to be seated. Note that in this position in the chair, she was able to place her feet on the floor and sit upright. Her left foot was crossed over her right, and this caused a foreshortened view of the near leg. It is better to have the right foot across the left in this pose because it makes the leg look longer and sleeker.

Note that the subjects in plates 131 and 132 are each holding a rose. This allowed Kerry to keep their hands where she needed them. For the best results with this technique, show the child how to hold the stem of the

Top left—Plate 130. *Top right*—Plate 131. *Above*—Plate 132. *Photos by Kerry Firstenberger.*

flower between the thumb and middle finger of each hand. This means that whatever our angle of view, the hands will be nicely presented.

In plate 133, we have a Wendy Veugeler portrait of a little girl seated on a posing chair. The difference here is that the child was seated with her legs almost straight out in front of the chair, and her dainty toes protruded from under her dress. This works well when the child is barefoot but is not recommended when she is wearing shoes. In this pose, the bottom of the shoes would likely show—and this is something we should strive to avoid. Note too that the child was posed at about 45 degrees to the camera so that her feet were not pointed at the lens. However, the angle of view caused the girl's left side to be partially hidden behind the sweep of the chair. A slight turn of about 10 degrees toward the camera would have allowed us to see more of the girl's left side. Nevertheless, this is a charming portrait.

In plate 134, Kerry Firstenberger positioned the child in a standing pose. This is always something of a challenge with children under six years

Plate 133. Photo by Wendy Veugeler.

 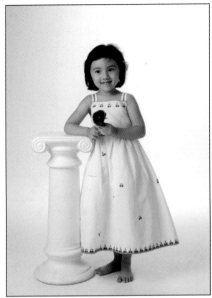

old, as we cannot be sure they will stay in place. Sometimes we may need to reposition them several times during a session. Note that the child's feet were positioned at about 40 degrees from the camera, which allowed her feet and legs to look their best. We need to avoid what may described as "duck's feet," which is what they may look like if they are square on to the camera. Though the child turned her body toward the camera, she was disciplined enough to keep her feet where they were posed.

In plate 135, Kerry retained the same standing pose and also employed a small pillar for the girl to rest her right elbow upon. She then brought the girl's hands together to hold on to a rose. Having a child hold on to a flower with both hands is an excellent method of retaining the entire pose.

■ Girls Six to Eight Years

In this section we will explore ideas for posing girls six through eight years old. Though boys this age are often a little rambunctious and more physical, girls in this age group are calmer and less exuberant (though there are exceptions). When photographing girls in this age group, we can employ fantasy and storytelling poses because they can now comprehend what we are seeking. Additionally, children this age will engage in conversation with us. This can help us to sculpt an image that reflects who they are.

In plate 136, we have a little girl who appears to be engrossed in a story. The book we chose for this portrait was a little advanced for the child's age and reading level, yet she had no trouble acting engrossed in the story.

Note how the girl was seated. The back of her knees were tucked into the edge of the full-sized chair, and this caused her feet to extend away from the chair. At the same time, we had her lean over the book with her arms resting on it. This created a nice triangular composition.

In plate 137, we see a portrait of a delightful little brunette. The girl was positioned in a seated pose, roughly 10 degrees off camera, and her legs

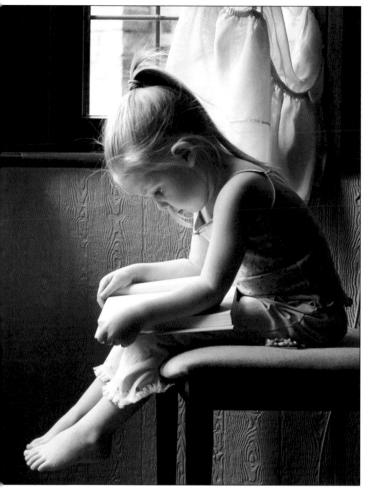

*Top left—Plate 136. **Top right**—Plate 137. **Left**—Plate 138. Photos by Norman Phillips.*

were perfectly positioned to create a tapered composition. Her hands were brought together in her lap, just as we would have them if she were an adult. The result is an elegant pose—one that a younger child might not present to us. Her interaction with us shows in her expression.

Plate 138 illustrates how much easier it is to work with an older child. The main prop, the white bench shown in some of the images presented earlier, was used in a different way than we have used it with younger children. In this instance, we had the girl seated with both legs on the bench and styled as if she were posed on the floor. The difference is that her left leg extended beyond the end of the bench and dropped slightly to create a nice curved composition. Note the way she rested her right hand on the bench and placed her left hand on her lower-right leg.

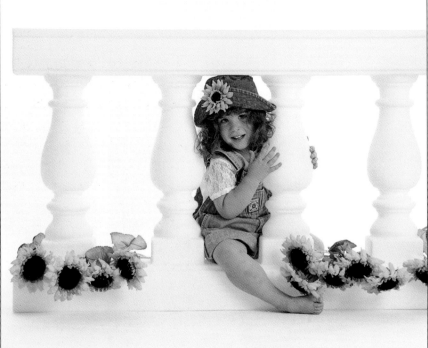

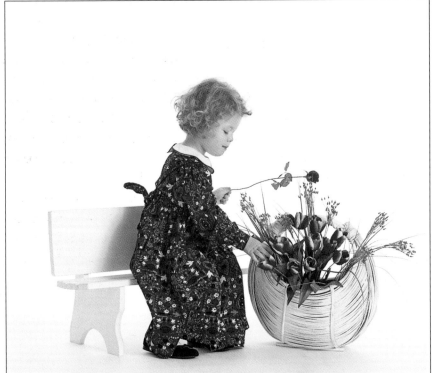

*Top left—Plate 139. **Top right**—Plate 140.*
***Bottom left**—Plate 141. **Bottom right**—*
Plate 142. Photos by Norman Phillips.

To create the portrait shown in plate 139, we seated the subject on a full-size wicker chair. Because her feet did not reach the floor, her legs were allowed to drape downward with her ankles crossed. This works well with a girl this age as she will always re-cross her ankles at our request should she inadvertently uncross them. Note too that our subject sat tall and was not too far back on the seat of the chair. The angle of the chair to the camera allowed us to present the girl in a three-quarter view.

The set we created for plate 140 would probably not have worked with a younger child as it required the girl to keep her right leg in front of the

prop and to hold on to the pillar—while having fun and looking happy. With younger children, orchestrating such a pose can be challenging and is sometimes simply unworkable, but using this prop and pose can produce some delightful images with the right subject.

In the portrait shown in plate 141, we used two props: our little white bench and a basket of flowers. Because of the child's age, we had no difficulty in getting her to arrange the flowers, and she was completely into the concept. Note how the bench was turned slightly away from the camera and the basket was almost square to the lens; this allowed us to achieve a profile portrait. You can see that this particular subject was a little taller than some of the other kids shown seated on this bench by how she placed her feet firmly on the floor.

The portrait in plate 142 is a spin-off from the pose in plate 141. We simply zoomed in for a close-up and had the girl turn toward us without changing her position on the bench. This demonstrates that when we have a sound basis for a portrait, simple adjustments allow us to expand our posing options.

Girls love to dress up and act like their mothers, and the portrait in plate 143 shows a little girl doing just that. We suggested that she is just like her mother and stood her at the head of a small couch dressed in a hat and coat with an appropriate black purse. Her right arm rested on the top of the bench arm, and her right foot was crossed over her left leg. All this was created with our direction, and she beamed with delight as she was truly into the fantasy we created. Note the angle of the couch, which enabled us to create this portrait and several others, including close-ups.

Plate 144 shows a portrait in which we employed a fantasy concept. A window set was used as the main prop, and the girl held on to it with her right hand and presented a very feminine pose as she focused on the flower she held. Because of her age, we were able to have her position her feet as

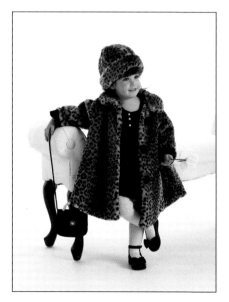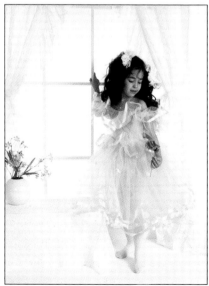

Left—Plate 143. **Right**—Plate 144. *Photos by Norman Phillips.*

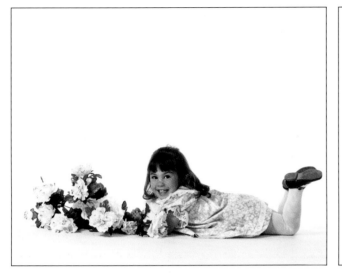

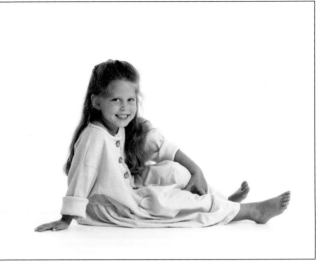

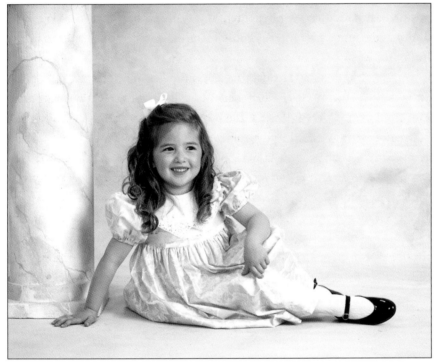

we would like them, with the left foot nearer to the camera than her left. This is a pose that works well for girls this age.

The pose shown in plate 145 is one of the easiest to obtain. We simply had the girl lay on her tummy, resting on her arms in profile to the camera. We then had her kick up her feet to create some feeling of motion. The flower arrangement was added to "pretty up" the image. It was very easy to have her turn her head toward the camera for this portrait.

The girl in plate 146 was seated on the floor, profile to the camera, and posed much as we might present an older female. She rested on her right hand, which was turned so that the side of it showed to the camera. Her right leg was extended, and she was encouraged to stretch her toes to avoid pointing them skyward. We then had her draw her left foot toward her to

create a nice break at the knee. Her left hand was placed on her knee. The result is a very simple but effective pose.

We have a variation of the same pose in the image shown in plate 151. We began with the position used in plate 147 but had the girl roll onto her right hip and slightly bend her right knee. Her right hand was moved farther to our left to create separation. Finally, her left leg was drawn slightly more upward than in the previous image so she could comfortably rest her left elbow on her knee. This created a very nice tapered view of her legs and feet and produced a comfortable position from which she could present herself to the camera.

In plate 148, we have another floor pose. To produce this portrait, we once again used the ideal leg pose in which the near leg is extended with the toe pointing forward and the far leg is slightly bent so that it shows above the near leg, creating a nice, tapered appearance. The pink parasol was held in her left hand, and its stem was brought across the near leg. Her right hand supported her seated pose. Girls enjoy using a parasol as a prop, so having one in the camera room is advisable.

In plate 149, we have a different and more active floor pose. The girl's arms were stretched out behind her, and both hands served as supports. The child's feet were pulled together and brought closer to her body than in the pose shown in plate 148; this caused her shoulders to hunch a little, producing a nice pose that is quite feminine, despite the fact that she was dressed in jeans. This is a fun pose that allowed us to produce a delightful portrait of an energetic young girl.

Previous portrait examples showed subjects posed facing the camera with their elbows resting on various props. In plate 150, the girl is shown in profile to the camera. This is a comfortable pose for most children this age, but we need to be careful not to show only the upper arm nearest the

Left—Plate 148. **Right**—*Plate 149. Photos by Norman Phillips.*

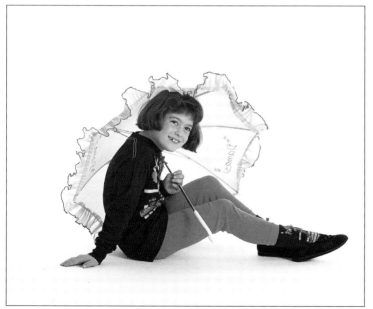
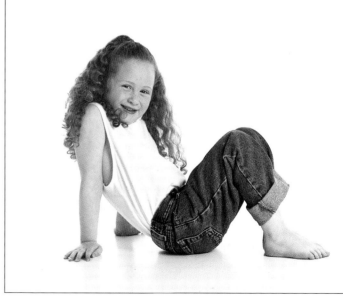

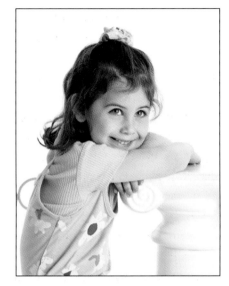

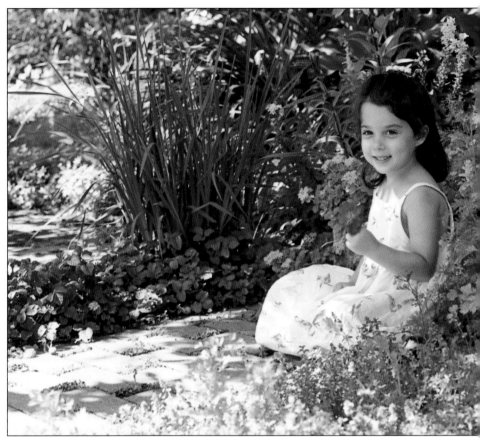

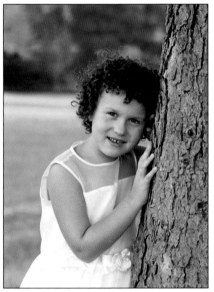

camera, as this is not flattering. Note that in this portrait, the girl's left hand shows beneath her right arm. Note, too, that her arms were crossed more closely than in previous examples. The result is a more peekaboo-style pose that was en-

Top left—Plate 150. **Top right**—Plate 151. **Bottom left**—Plate 152. *Photos by Norman Phillips.*

hanced by her playful smile. In this pose it is essential to have the seat at just the right height. If the seat is too low for your client, simply place a pillow or other riser on the seat to achieve the desired height.

Outdoors, the ground is often uneven, and many children feel uncomfortable when positioned in some of the poses described earlier. In such a case, using a cross-legged pose is acceptable. The child in plate 151 was posed in a garden in this manner, and the result is charming.

Trees oftentimes make great outdoor props, and we used one in plate 152. To create a gentle sloping composition, we had the girl stand about a foot or so from the tree and had her lean in toward it. Her left hand, which is hidden from view, provided the main support for the pose. Using the left hand as the main support allowed the right hand to rest delicately against the tree. Note that positioning her hand no higher than her chin level produced a nice bend in her arm and kept her hand from detracting from the focus of the portrait.

In plate 153, we again used a tree as a prop. This young lady advised us that she was going to be an actress when she grew up, and she definitely demonstrated her talent on the set.

We had the subject put her weight on her back foot with her toes pointed toward the camera, then bring her other leg across it. She rested her right hand on the tree and leaned slightly toward it. By having her place her left hand on her hip, we were able to create an exaggerated pose that's full of drama. It's the kind of pose that girls around this age can step into with a little direction as they have the discipline to hold the pose.

We once again used a tree as the prop in plate 154. Our young subject was seated on the sloping ground in front of the tree with her right leg bent at the knee so that it was positioned horizontally to the camera. Her left leg extended slightly diagonally to our right to create a nice leg pose. We requested that she place her hands on her knees, which she did—and although they are not perfectly posed, the fact that she is young allowed us to get away with a less-than-ideal pose of the hands. We would not allow this hand pose if the subject were an adult.

Left—Plate 153. **Right**—Plate 154. *Photos by Norman Phillips.*

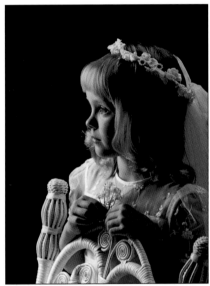

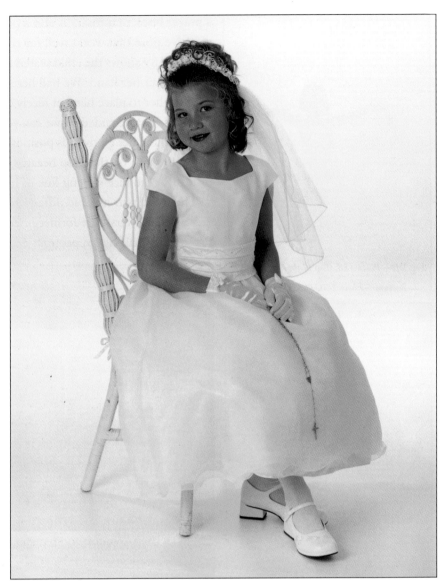

holding on to her prayer book; in plate 160, we were able to show how delicately she held on to the flower, gently grasping the stem with her fingers. Such a feminine, graceful approach is desirable; we need to avoid having our subjects grasp accessories in a way that presents an unflattering view of the hands.

In plate 161, we took a slightly different approach to a confirmation pose. Though the girl's pose resembles that used in the previous portrait, she is in a more relaxed style with the fingertips of her right hand resting on the prop and the fingers of her left hand slightly curled and resting high on the side of her face. The position of her arms and hands creates a circular design that leads to her expression. Note that the prayer book and rosary are fully visible and are important elements in the portrait.

Plate 162 is a profile portrait in which we used a chair and a sprig of flowers as a prop and accessory. The child was positioned at approximately 45 degrees to the camera to provide a wider base for the profile head posi-

Top left—Plate 161. **Bottom left**—*Plate 162.* **Above**—*Plate 163. Photos by Norman Phillips.*

tion. Her hands were placed on top of the back of the chair with the sprig of flowers held between her fingertips. Having her rest her hands on the chair back, rather than grip it, allowed us to create a relaxed look.

Plate 163 shows a simple and elegant seated pose. The subject's gloved hands rested nicely in her lap without any over posing. Her feet were correctly posed to achieve the desired tapered look. By having her turn her head about 45 degrees away from the camera and tip it slightly toward her near shoulder, we produced a traditional ("submissive") feminine head pose that flattered the subject.

■ Boys Four to Six Years

Little boys in this age category vary enormously in their behavior. They can be shy, passive, boisterous, and even wild, and many will separate themselves from some of the things that they previously had in common with their same-age sisters. When these children arrive for their sessions, we should be ready for anything to happen.

One of our ploys in the camera room is to ask each of these subjects, do you have a girlfriend? Their responses vary from a sneer, to horror, to embarrassment—and are at the very least entertaining.

In plate 164, we had several stools available, and this subject chose the smallest of the set and immediately straddled it as if he were on horseback. This in effect is a self-created pose and is representative of the kind of response we may get from a boy on the set. Clearly, the stool was too small for this fellow, but he was having fun, and as that is what we wanted from the session, the portrait is successful.

The formally attired subject in plate 165 is a character of a different ilk—calmer, assured, and very happy in this pose. We built two blocks into a prop and posed him in a style that is not fundamentally different from what we might use for an adult. His left arm rested on the top of the prop while

*Left—Plate 164. **Right**—Plate 165. Photos by Norman Phillips.*

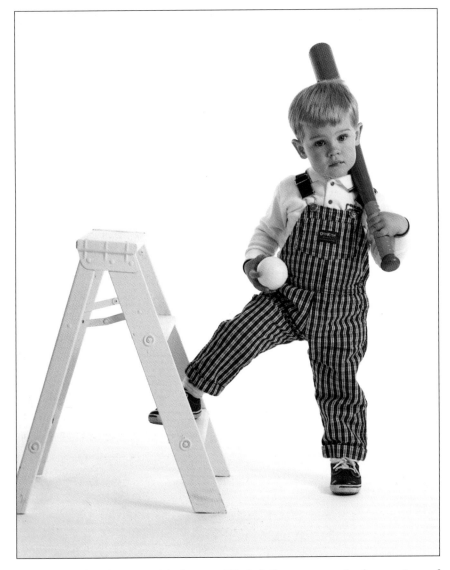

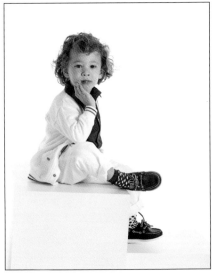

*Left—Plate 166. **Above**—Plate 167. Photos by Norman Phillips.*

he held the hat between his fingers. His left foot was on the lower riser of the prop in a style that's a little childish compared to the way we would have him if he were an adult. His right thumb was hooked into his trouser pocket to complete the pose, which mirrors a position that his dad might fall into quite naturally.

In plate 166, we continue the trend of employing poses we could use with adults. In this instance we used a small ladder as the prop. Clearly, the height of the lowest step was a little too high for this little man, and this caused him to exaggerate his stance when placing his right foot on the ladder. The ladder and the right foot were the primary elements in creating this exaggerated impression; everything else simply fell into place. The toy baseball bat and the ball were the finishing elements in the pose.

We once again used one of our blocks as a prop to create the pose shown in plate 167. The boy was seated profile to the camera, and his right foot was brought up and onto the block. This allowed us to bring his knee into position so it could serve as a rest for his elbow. His open hand was then

used to prop his head up in a very sophisticated manner. This arrangement brought the boy into a very effective presentation to the camera. The result is a very traditional presentation of a young boy in a relatively modern context. The personality of the subject made this pose possible. Because he could communicate with us and was happy to work with us, this image is a success.

In the portrait shown in plate 168, we managed to present the boy in an adultlike pose without losing the innocence of the child. We used a small pedestal as our prop and had him lean his left elbow upon it to create the kind of stance that an adult may well take up. We often tell young boys they are posing just like their dad. The idea is very appealing to a majority of boys this age. The subject's left foot was kicked over his right so that his toe rested on top of his right foot. This is the child's edition of this pose; an adult would have his toe on the floor. To create the finishing touch, we had the little guy hook the thumb of his right hand into the belt loop of his trousers.

In plate 169, we used a posing concept similar to that shown in plate 167. In this portrait, the boy was seated on the lower of the two blocks so he could rest his right arm on the top block and place both feet on the floor. Note that his feet were separated so they did not merge into a solid mass of black. His left foot was drawn all the way back to the box, and his right was slightly extended to provide a longer line. His left hand was

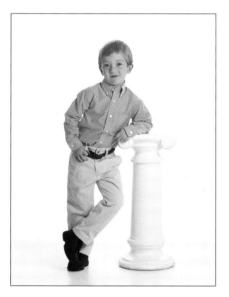

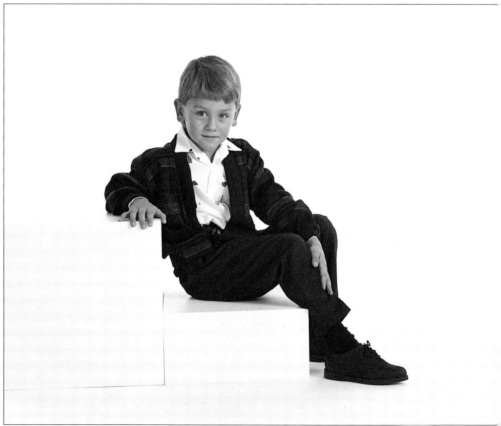

Above—Plate 168. *Left*—Plate 169. *Photos by Norman Phillips.*

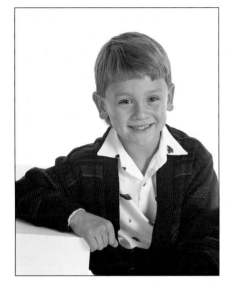

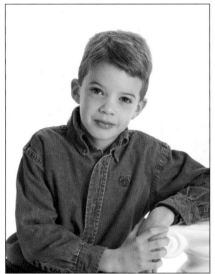

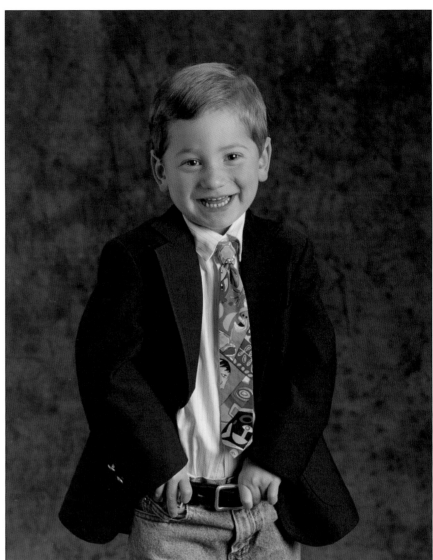

placed on his right leg to bring him around to face the camera and complete this very pleasant composition.

In plate 170, we modified the previous pose to create a close-up portrait. We simply brought the boy's hand across the plane of the camera and zoomed in. This demonstrates that when we have a sound basis for portrait, simple adjustments allow us to expand our posing options.

Plate 171 is a variation of similar poses previously discussed. The boy was seated with this right arm resting on our prop. His right arm was positioned across his body, and his right hand gripped his left. While the back of the hand shows, this is suitable for a male subject. When photographing girls, it is generally desirable to produce a more delicate hand pose.

The little character shown in plate 172 was positioned in a spot of our choosing, then we had him hook his thumbs behind his belt. The childlike fingers help to put an endearing spin on a pose that a grown man might fall into quite naturally. The fact that his clothes do not quite fit makes this a delightful portrait for his parents.

Top left—Plate 170. **Bottom left—Plate 171.**
Above—*Plate 172. Photos by Norman Phillips.*

Plate 173 shows a smaller child posed with a prop that was a bit oversized. He had to raise his arm slightly above his shoulder to use it as a support, and this automatically put his weight on his arm. The subject's right foot was brought across his left, and his toe rested atop his left foot. His left thumb was hooked into his trouser pocket. We rarely have any difficulty in posing boys in this style. We place them where we need them on the set, then position each limb and, presto, the pose is complete.

Plate 174 shows a variation on the previous pose. The boy, a ring bearer at a wedding, was dressed in his tuxedo, complete with boutonniere. We used a side table, which was just the right height for this little fellow, as our prop. To create a relaxed, confident mood, we positioned his right hand over the edge of the table and brought his left hand, cupped in a gentle fist, over to his lapel. His right foot was crossed over his left, but rather than have him rest his toe on the floor we had him place his foot on the floor, which caused it to rest on its side. It is a nonchalant pose for a small boy.

The next few portrait examples were shot on location. Plate 175 shows a boy posed reading a book while seated on a couch. When creating this type of portrait, there is a temptation to have the boy place the book in front of him with both hands holding the book. Here we had him rest his left arm on the arm of the couch and hold the book in his left hand. His right elbow rested on his right leg, and his right hand was brought under his chin to create a studious pose. Positioning his right arm in this way caused him to lean slightly to our left, and the resultant angle of view created a dynamic composition.

*Top left—Plate 173. **Bottom left—** Plate 174. **Bottom right—**Plate 175. Photos by Norman Phillips.*

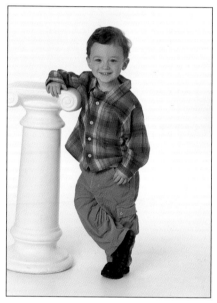

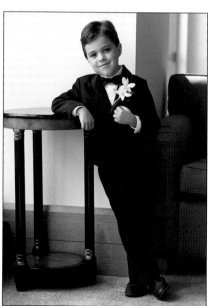

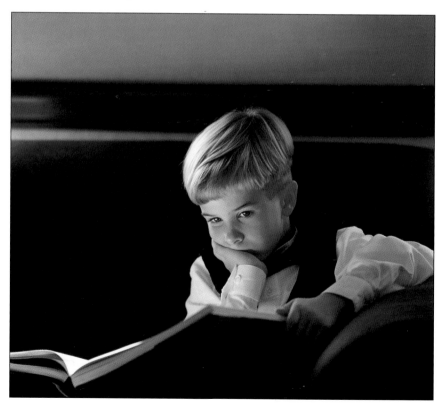

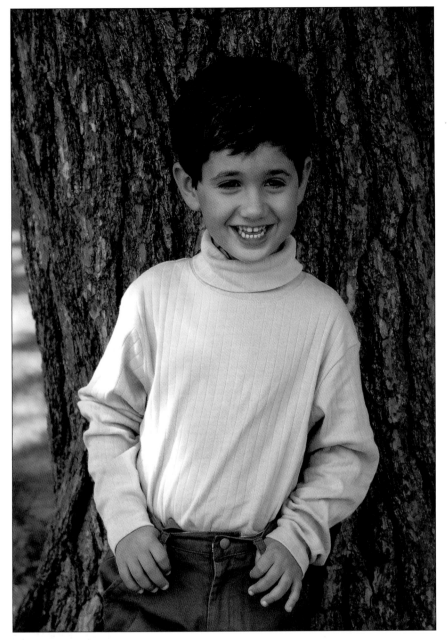

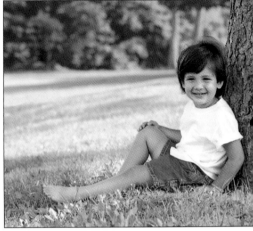

Left—Plate 176. *Right*—Plate 177. Photos
by Norman Phillips.

As noted previously, trees make good props, and we used one in plate
176. We had the boy stand with his back against the tree. Though we can-
not see his feet, he was positioned with one foot crossed over the other. In
a previous example, we had a boy with one thumb hooked through a belt
loop, and this little guy was posed with both thumbs hooked onto his belt
loops. This is an easy pose to create.

A tree was again used as a prop in plate 177. This time the boy was seat-
ed on the ground and leaned against the trunk. His right foot was posi-
tioned at the knee of the left leg. His right hand was placed on his right
knee, and his left hand was placed beside him, with his elbow slightly bent
to avoid forming a straight line from his hand to his shoulder. This is a sim-
ple pose for a child.

Plate 178 shows the result of our patience in attempting to freeze a very active, energetic, and expressive child in his own home. We managed to place him between two pieces of furniture (which seemed a sort of trap) with his right hand on a chair and his left elbow positioned on the table-top. At the sixth or seventh attempt, we froze this pose, which truly portrays the child's personality. The two props were ideally placed to keep both hands in a stable pose.

The set for the portrait shown in plate 179 was three walls. The boy was placed at the most dynamic point in the set and leaned against the wall in a profile pose. We once again used the crossover foot position to create the base for the pose and had him place his hands in his pockets. There is a diagonal line that runs from the portraits on the wall to our left through to the subject's feet that aids in the strength of the composition.

Above—Plate 178. **Right**—Plate 179.
Photos by Norman Phillips.

We return to the pedestal as a prop in plate 180, a Kerry Firstenberger portrait. The pose is a variation of previous poses made in a similar style. The boy was placed close to the pedestal and turned slightly toward the prop so that he could comfortably rest his right arm on its top. His left hand was brought over his right. The key difference in this variation is that the subject was not turned directly toward the camera as in previous examples. Note that Kerry used the same foot pose seen in previous portraits, but because the boy's angle to the camera was different, the resulting portrait has a distinctly different perspective.

Another portrait by Kerry Firstenberger is shown in plate 181. To create this image, Kerry had her subject rest his elbows on top of a pedestal. His right hand was placed flat on the prop, and his left hand was posed over his right wrist with his head dipped just behind his

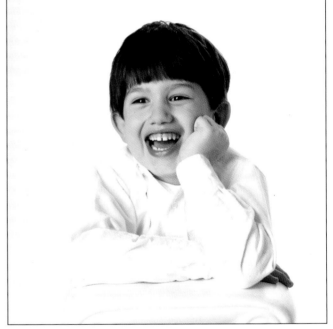

Top left—Plate 180. **Top right—Plate 181. Bottom right—Plate 182.** *Photos by Kerry Firstenberger.*

hands. Young subjects can easily retain this pose for a series of images, and to produce the pose shown in plate 182, Kerry simply had the boy bring one hand to his face to change the style without having him do anything radically different.

In plate 183, Kerry Firstenberger employed a small ladder as a prop and sat the boy on the top with both feet on the same level at about 45 degrees

to the camera. This allowed her to place his left arm across both knees. To finish the pose, she had him rest his right elbow on his right knee.

The next three portraits are also by Kerry Firstenberger. In the first two, the back of the chair was used as a resting place for the boy's arms. In plate 184, his right arm was positioned over the back of the chair, and his left hand rested on top of the other. To take up this position, the boy was seated sideways on the chair. Note that both arms were presented in the same linear position, though on different sides of the chair back. The pose is very masculine, and because it is very easy to take up this position, it is frequently used when posing males.

Plate 185 shows the boy on the same chair, again seated sideways. The difference is that, for this portrait, Kerry had him positioned in a three-quarter view to the camera with his right arm resting on the chair back and his hand tucked over its edge.

In the floor pose shown in plate 186, Kerry's subject assumed a cross-legged position facing the camera, then placed his elbows on his knees and

Top left—Plate 183. **Center—Plate 184.**
Bottom left—Plate 185. **Bottom right—**
Plate 186. Photos by Karen Firstenberger.

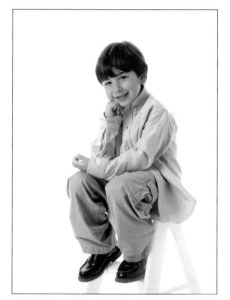

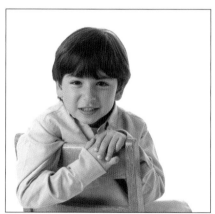

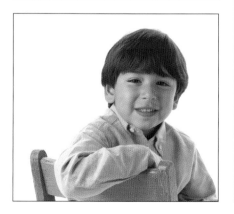

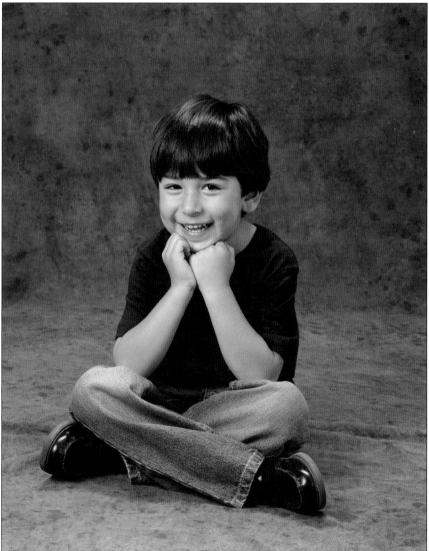

rested his chin on his hands. The pose is the epitome of simplicity. Though it is a little symmetrical, it is nonetheless very pleasing.

To create the portrait shown in plate 187, Wendy Veugeler posed her subject on a window sill with his hands open and cradling his face to create a frame for his expression. When posing a child in this manner, the correct placement of the elbows is critical to the success of the image. In this instance, the boy's elbows are positioned on the sill, slightly in front of his face; if they were too far in front or too close to his body, the subject would not appear as relaxed, and the portrait would not be as appealing. Likewise, choosing a seat that is well suited to the size of the subject will ensure that he looks comfortable in the pose.

■ A Final Note
Though you might expect to find a section on boys at the upper end of this age group here, the truth is, boys this age are seldom photographed. For simplicity's sake, a discussion of posing boys aged seven to thirteen is presented in the next chapter.

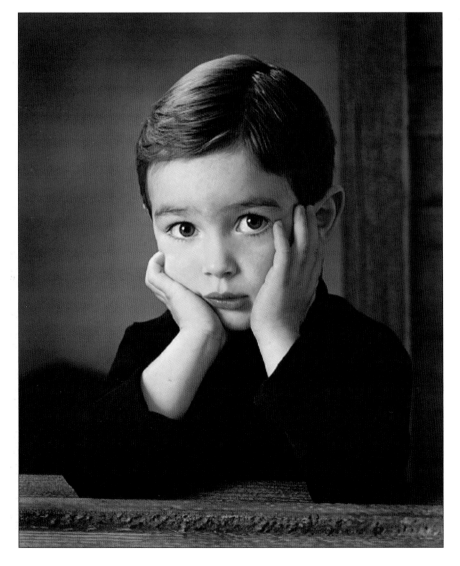

Plate 186. Photo by Wendy Veugeler.

3. Preteens and Teens

Presented in this chapter are poses that work for preteens and early teens. I have found that many children aged nine and up are, from a posing aspect, almost as mature as their teenage siblings. Though older children often physically appear like adults, because they are still mentally and emotionally immature, we must employ an appropriate posing psychology if we are to obtain the best results.

■ Girls Nine to Ten Years

Because females in this age range develop faster than they did in earlier times, they tend to be more sophisticated and take on the attitudes and mannerisms of their elders. Consequently, some of the poses we use with their older relatives can be good posing options for this group. (For tips on effectively posing adult females, see *Professional Posing Techniques for Wedding and Portrait Photographers* [Amherst Media, 2006].) We must make judgments about how we pose them based on psychological assessments or a consultation with their parents. Though they may seem relatively mature, we must also beware the temptation to pose them in a provocative manner.

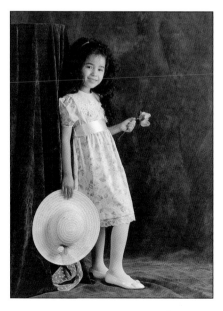

Plate 188 shows a little lady in a sophisticated pose leaning against a draped wall. She held a rose in her left hand and extended it away from her. In her right hand she held a hat (we would not have allowed her arm to be so vertical if she were not holding the hat). Her feet were posed to complement her profile presentation to the camera. The pose is elegant and one that most girls age nine and older are able to present when directed. You can see how relaxed and comfortable the subject appears in this pose.

Plate 188. Photo by Norman Phillips.

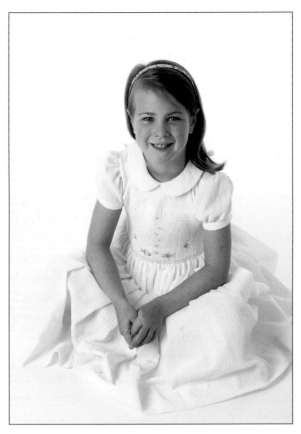

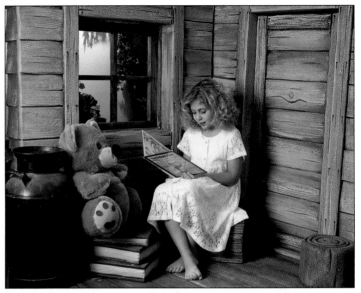

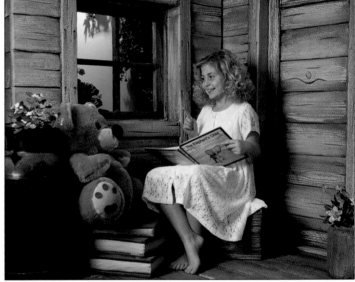

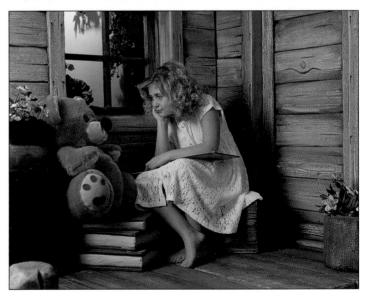

Above—Plate 189. **Top right***—Plate 190.* **Center***—Plate 191.*
Bottom right*—Plate 192. Photos by Norman Phillips.*

When we need a more casual pose, the one shown in plate 189 will often work very well. To create this image, we had the girl seated cross-legged on the floor and ensured that her dress covered her knees and feet. Her hands were placed comfortably in her lap. It is a simple yet pleasant pose. Note that for this pose to be effective, the camera must be positioned just above the child's head level with the lens pointed down at the subject.

In the next series of images, we indulged in a little fantasy. We placed the child in this rustic set and asked her to read the teddy bear a story. Note how her angle to the camera in plate 190 allowed us to produce a view that is neither too wide nor too narrow. The angle of view also presents the book to best effect, as we can see that its pages are open. By having her cross her right leg over her left, we produced a nice long leg line. Plates 191 and 192 are natural extensions of plate 190.

Plate 193 shows the subject in a more casual floor pose. To create the image, we had the girl sit on the floor, facing the camera, and rested on her right hand, which was slightly extended away from her to our left. Her legs were slightly tucked toward her, which allowed us to have her bring her left leg over her right and taper them to our right. There is a line that runs from her left shoulder sweeping down toward her toes, while her head is slightly tilted to our right to create a nice curve.

In plate 194, we have the same subject with both arms resting on the seat of a chair. They were brought together so that we could position her hands one over the other. In this position we would not have the right hand over the left as it would show only the back of the right hand, and not the fingers—and this is undesirable.

Plate 195 is a conventional bust portrait. We have not included hands or arms or shown any kind of prop. It is a portrait that we might well see fairly regularly on mantels or atop pianos in most homes. We seated our subject on a bench that was angled approximately 20 degrees off camera, and it was easy for her to address the camera from this position. We did not use the traditional female head pose; instead, we had her tip her head slightly toward the far shoulder. Personally, I prefer this position, as I believe it brings most of my subjects to life. It causes the subject to change from a quiet, almost dreamy presentation to one of interest.

Top left—Plate 193. Bottom left—Plate 194. Bottom right—Plate 195. Photos by Norman Phillips.

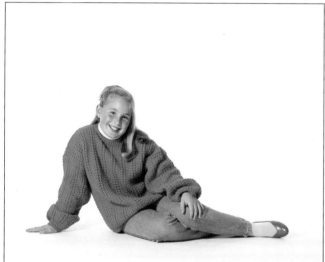

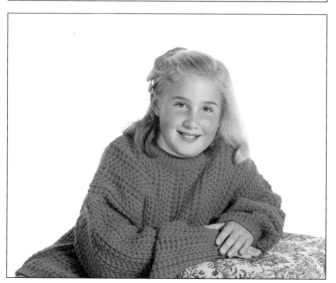

In the portrait shown in plate 196, we posed the subject in a profile position so when she turned her head toward the camera it automatically tipped to the near shoulder. However, this did not create a submissive impression because the expression is more questioning or skeptical. If the subject were posed on a rotating posing stool, we could have produced a series of images with differing head positions and expressions by slowly turning her toward the camera.

The subject in plate 197 was posed near a window with her right forearm resting on the arm of a chair. Unlike some of the similar poses shown previously, in this image, the subject's left hand is underneath her right hand, and only the palm of her left hand is placed on the chair allowing her right hand to rest on top of it. We have in fact broken one of our golden rules by having the fingers of her top hand coming toward the camera, but because they are at a slight angle and point to the bottom-right corner of the composition it has not foreshortened the fingers and is acceptable.

*Top—Plate 196. **Above**—Plate 197. Photos by Norman Phillips.*

■ Girls Eleven to Fourteen Years

At this age, there may be little difference between some of our "girls" and young women. The great majority of girls this age are much more aware of who they are, and often their physical development presents a very mature subject to work with. In some instances, these females present a provocative expression or body language. In this chapter, we will only gently touch upon such poses; we will focus our attentions on poses that allow these young women to express their femininity without being overly provocative.

Cheerleading is a sport that is popular with many girls this age and beyond. When photographing these enthusiasts, we want to show off their cheerleading exercises and athleticism.

In plate 198, we used a pose that promotes the subject's athleticism. By having her positioned profile to the camera with her far leg outstretched and her toe extended, we created a very sleek base to the pose. We then had her place her right hand twelve inches or so behind her and turned her shoulders toward us. Her left elbow was posed on her left knee, and her left hand was positioned at the side of her head. The dynamic line that we created in posing her near leg and foot is a key element in the pose. The result is an attractive portrait of a cheerleader in her uniform.

In plate 199, the subject was posed in profile to the camera. By turning her head back toward the lens, we achieved an almost full facial view, and as a result, her left forearm and hand draw the viewer's gaze to the focal point of the image. There are two key elements in the success of this pose: First, there is an attractive composition that results from the posing of her hands and arms, and we could create an attractive head-and-shoulders portrait if we chose to zoom in. The second successful element is the way the girl raised her feet and the space she presented between them. This created a compositional design that is very feminine and attractive.

In plate 200, we show one of the many poses that can be used to show the interests and physique of a girl interested in gymnastics. The subject was presented in a preparatory position on all fours. The positioning of the girl's hands allowed us to show her in a three-quarter presentation. Note too that her hands and arms are on the same plane as her legs. The pose

allows us to see her pretty shoulders and arms and her lovely smile, but it also allows us to focus on her athleticism.

To create the image shown in plate 201, we employed a window set as a prop. (If you do not have access to such a prop, you can use a pedestal, railing, or fire escape for similar results.) Here, the subject was posed square to the camera. While this is generally not advisable, using the subject's arms and hands as key elements in the composition made her position acceptable.

The young lady held on to one of the vertical supports with her left hand, showing her fingers rather than the back of her hand, for the best-possible view. Note that the height at which her hand was positioned allowed us to produce a gentle sloping line in her forearm that leads the viewer's gaze to her face. She tipped her head toward her left hand, and this allowed us to show her beautiful hair to best effect. To complete the pose, we had her place her right hand on her hip; this is a position that females may fall into in everyday situations.

Left—*Plate 201.* **Top right**—*Plate 202.* **Bottom right**—*Plate 203. Photos by Norman Phillips.*

Plate 202 shows the subject seated in profile with her head turned toward the camera with an attractive smile. The way her arms and hands were posed was key to the success of the image. By having her right hand on the seat just behind her and her left hand at her right knee, we created a triangular composition. Had her hands been in a passive position at her knees, the portrait would be boring and ordinary.

In plate 203, we have a slightly foreshortened view of the client's right arm. While we played with fire, we can excuse ourselves for breaking the rule as the subject has a delightfully playful appearance. Our subject was seated approximately 45 degrees off camera with her left hand resting on the seat. Her right hand was positioned on the upper area of her right leg, and she turned her head to achieve a three-quarter view and deliver the broad smile. It is a simple but effective pose.

Plate 204. Photo by Norman Phillips.

When working with preteens and teens, we may well be able to produce a portrait with a lot of sophistication, as demonstrated in plate 204. We positioned the young lady at approximately 50 degrees off camera with her head turned to produce a three-quarter facial view. Having her hold her glasses in front of her at the bottom left of the composition completed the pose. Note that positioning her head in a much more vertical pose presented an elegant and businesslike attitude. This portrait suggests that this young lady has a mature confidence, and we can create this impression when we have the right subject.

Some young ladies are more extroverted than others, and when working with such subjects, we might consider using a pose that is appropriate for boys of the same age. To ensure that they do not look masculine, however, we should make some slight refinements. Plate 205 shows a young lady posed on a lifeguard's station. This preteen is very happy to be something of a tomboy, and she looks comfortable and con-

Left—*Plate 205.* **Right**—*Plate 206. Photos by Norman Phillips.*

fident in this pose. Except for the fact that her left leg appears very straight due to the space between the horizontal bars, the pose is very pleasant. We could have created a few more curves by having her tip her head and slightly turn her shoulders, but this pose worked with the girl's personality.

Though females can look very attractive in poses that we use for males, it is not acceptable to pose boys and young men like girls and young women. While males may cry foul, that's just the way it is.

In plate 206, we brought the subject to the ground. The horizontal bar of the chair was used as an armrest, and her arms were nicely placed. Although we do not have a full view of her legs in this image, we can see that her right leg was positioned as in the previous portrait. This is another pose that would be appropriate for boys but is equally adaptable for girls.

Plate 207 shows a pose designed for a bust portrait. We employed a prop with an interesting curve that allowed us to pose the subject's right arm in a sloping line away from her shoulders, then had the subject gently rest her face on her right hand to prevent any distortion of her features. We had her bring her left arm across her body and created a break in the left wrist that prevented the formation of a rigid line across the image. The diagonal formed by the young woman's left arm leads to her face. Note that the lines in the portrait lead us to her smile no matter where we start our view. This is a relaxed and comfortable pose.

Plate 208 shows a pose that is a little more daring than most, as the subject's hands and arms served as important elements in the pose. When

using the subject's hands in this manner you must be very careful that they do not look like dangerous weapons, as they are very prominent in the composition. Here, we created a break at each wrist to alter the vertical lines of her arms. Her hands were slightly fanned out so they did not create a solid mass beneath her face. At the same time we had her lean toward our left with her arms slightly away from her body to create a sloping line away from her shoulder. Note, too, that we had her rest her face gently on her hands so that they did not distort her features.

Plate 209 is an elegant portrait of a young lady in a beautiful dress. To properly show the dress in the image, I had the young woman positioned directly facing the camera. Though this is something I rarely do, because of her special persona and presentation, I felt able to do this without compromising my posing standards. Her hands were positioned to the sides of her hips to create a triangular composition from the seat to her head. Her feet were positioned so that her left foot was a few inches in front of her right. This positioning partially hid her back foot and created a very attractive tapered look. To finesse the pose and break the vertical line of her torso, I had her move her left hand a little farther from her body and lean slightly to her left, then tip her head to her left.

*Top—Plate 207. **Bottom left**—Plate 208. **Bottom right**—Plate 209. Photos by Norman Phillips.*

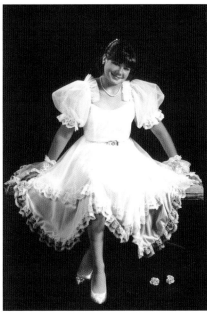

■ Boys Seven to Thirteen Years

You might wonder why we cover such a wide age range in this section. The answer is simple: First, at age seven or eight, many boys are photographed for their first communion. Bar mitzvah boys are photographed at age twelve to thirteen, and we make portraits of them in formal attire. Between the ages of eight and twelve, boys are seldom photographed, unless it is with their sports attire or equipment. Second, after the age of twelve or thirteen, we can use the poses recommended

for adult males. For more on posing adults, see *Professional Posing Techniques for Wedding and Portrait Photographers*, also from Amherst Media.

The image shown in plate 210 is a boy's first communion portrait. Two factors influenced the way we posed this subject. First, we wanted to ensure that his jacket and tie were not in disarray, so we kept him as upright in his seated position as possible and posed his arm on the pedestal in as relaxed a way as possible so as not to cause ugly folds in his jacket. Second, we wanted to ensure that he held his prayer book in a masculine position. His left hand was allowed to comfortably fall over the edge of the prop.

The pose in plate 211 is not unlike many we have previously discussed. The difference is that, because the boy is older, he was able to assume leg positions that showed greater strength. He was positioned against a tree with his hands in his pockets just as his dad might be posed. It is worth noting that younger boys often push their hands deep into their pockets, causing their clothes to be a little ruffled, but boys at this age do not do so.

Left—Plate 210. **Top right—***Plate 211.* **Bottom right—***Plate 212. Photos by Norman Phillips.*

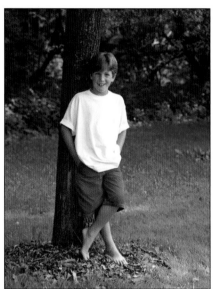

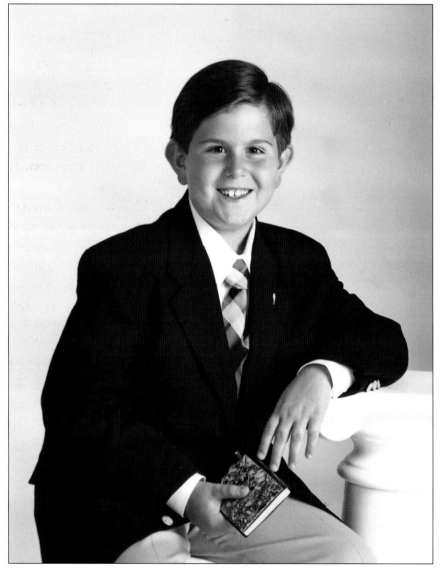

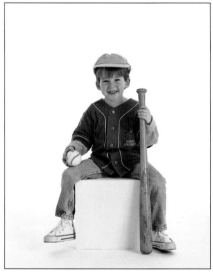

*Top left—Plate 213. **Bottom left**—Plate 214. Top right—Plate 215.*

Photos by Norman Phillips.

The boy in plate 212 was posed with a baseball bat and ball. He sat astride the box with confidence and comfort. The pose is brazenly male—and happy too. As you can see, it was also simple to create.

The pose shown in plate 213 is another first communion portrait taken on location at his celebration party. Again, we needed to ensure that his jacket and tie were correctly shown, so he was positioned standing at a window with his left arm on the ledge. Note how we posed his hands with his right gripping his left as it falls over the ledge. This is a typical male position that worked well for this portrait.

The portrait shown in plate 214 has the boy seated on the floor with his left arm resting on an upholstered stool and his left hand supporting his face. His right hand was placed passively on the stool below his head to create a nice line from his hand through his left arm and to his face. The pose is relaxed and comfortable.

The portrait in plate 215 is a simple, straight-on pose, because when a bar mitzvah boy is wearing his prayer shawl it is important to show both sides clearly and also ensure it is unruffled. The danger in trying to be too creative with this particular type of portrait is that the importance of the prayer shawl will be diminished or can look uneven.

The portrait in plate 216 is a variation of poses previously discussed. Now that we have a boy ten or older we can have a more elegant and masculine portrait and at the same time keep his clothes in good order.

His left arm was positioned atop a high stool. The height of the prop was important, as he was able to rest his arm without leaning too far over. Note that this position created a nice line from his head to toe. His left hand was posed in a gentle fist, placed just over the edge of the stool. His right hand was tucked into his pocket, with his jacket thrown behind his pocket to expose his shirt and the front of his dress trousers. The final and defining element in the portrait was the position of his feet. Instead of having him kick his left leg over the right and rest the toes on the bottom foot, the left foot was placed on the floor in front of his right foot, which supported his weight. This is almost a fashion-type pose.

When working outdoors, we have the opportunity to create casual poses that won't work indoors. To create the final two images in this chapter, we used the same prop and created two different poses with the same subject. In plate 217, the boy leaned against the frame of the prop and rested his left foot on one of the horizontal bars while supporting his weight with his other leg. His thumbs were tucked into his belt loops. Because he is barefoot and on sand, his baggy clothes and the pose are in tune with each other.

In plate 218, we changed the boy's angle to the camera by turning him into a semi-profile pose with his right foot on the lowest horizontal bar. He leaned on his right arm, which created a relaxed impression, and the thumb of his left hand was hooked into his pocket. This pose was perfect for this young man, who was a little shy and reserved. He appears relaxed and comfortable.

Plate 216. Photo by Norman Phillips.

Plate 217. Photo by Norman Phillips.

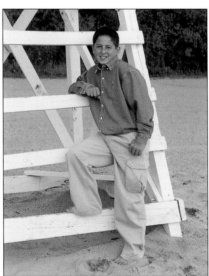

Plate 218. Photo by Norman Phillips.

4. Groups

■ Small Children and Babies

Posing children—especially small children—with babies can present some of our biggest challenges. Small children have little concept of what we are attempting to achieve so we are unable to explain what we have in mind. Add to this the fact that small children have less motor control, and you can see the problem.

When working with such groups, then, we have to create sets or arrangements that make it easy to place the baby and the small child in a way that will allow us to see both adequately and still have a presentable portrait for their parents.

The simplest solution is to place the baby in position so that he or she is presented acceptably to the camera as is shown in plate 219. Note that the baby was positioned on a posing pillow with a slight downward slope. We then placed the little girl behind the baby in a cross-legged pose. The composition may not be an award-winning one, but it is simple and effective. The composition requires us to have a slightly elevated camera position.

Plate 219. Photo by Norman Phillips.

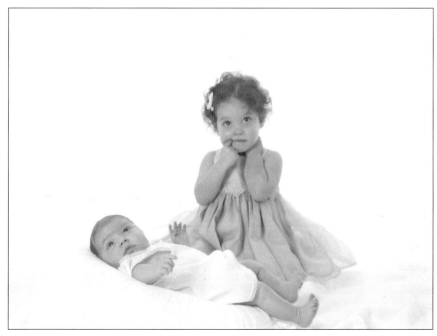

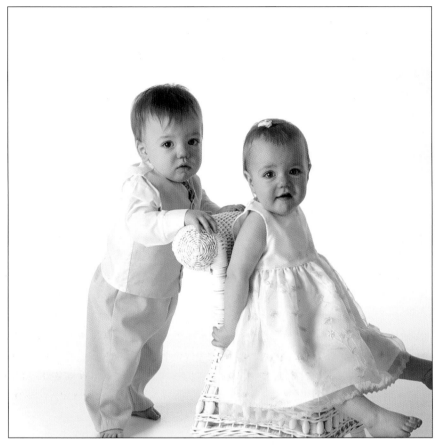

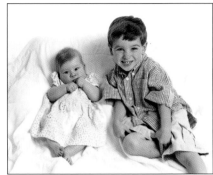

Left—Plate 220. Photo by Sam Lanza.
Above—Plate 221. Photo by Norman
Phillips.

This basic set can be expanded to include a basket in which to pose the baby. The child could be placed behind the baby. Often, when we set up such a pose, the older child will naturally interact with the little sibling. If you return to plate 113 (see page 51), you will see a basket setup behind which a small child could be posed.

Sam Lanza used an interesting concept to create the portrait shown in plate 220. At this young age, the tots had no concept of what Sam was seeking to achieve, but he handled the challenge nicely. He placed the younger of the two subjects on a chair, profile to the camera. This is a little daring as the baby on the chair is perhaps not more than four months old and could easily fall. Sam then positioned the older child at the back of the chair because, at this age, he was not confident about standing without something to hold on to. This also caused him to stay put. The composition is innovative, brave, and effective.

In plate 221, the baby was positioned on a special inclining prop facing the camera. She looks a little like a doll; her feet were together, and she had her hands at her mouth as can be expected. Next, her brother was positioned to her left with his right leg underneath his left, which was extended. This made him comfortable and enabled us to tip him toward his little sister. When we photograph a child of this age, we cannot be sure what he will do with his hands, but so long as he does not change his position we can get a few nice portraits.

Plate 222 is an extension of the pose shown in plate 221. This time we positioned the baby in a similar position and brought her older sister into a loving, close pose. We had her place her hand on the baby's tummy and presented the young subjects cheek to cheek.

Photographing babies and small children plus dogs can be a real challenge. Plate 223 shows a portrait of two dogs and a baby—none of whom have any communications skills. We needed to set something up to get them all to address the camera. The simplest solution was to arrange them in a straight line across the plane of the camera. The baby was just able to sit without support, and we had the sibling positioned on his knees.

Plate 224 shows the older sibling positioned on his knees behind the baby, who was posed on his tummy. The older sibling was posed with his knees astride the baby so he could place his hands on the floor immediately behind the baby's shoulders. This is a popular pose for children in this age group.

Mothers often want to have their baby sit for their portraits—even when they are not yet able to do so. While we will counsel them that it is not a particularly good idea, we sometimes need to acquiesce. This means we have to depend on older siblings to cooperate; sometimes this works and sometimes it does not. In the next four examples, all from the same session, three different posing formulas were employed.

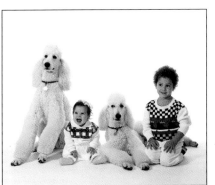

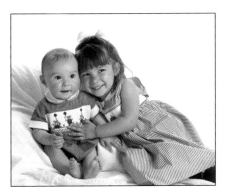

*Top left—Plate 222. **Bottom left—**Plate 223. **Right—**Plate 224. Photos by Norman Phillips.*

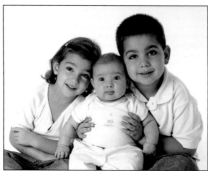

In plate 225, we seated the baby on the floor between the two older siblings. The boy acted as the support for the baby, who was unable to sit up without help. This arrangement worked for a few moments, allowing us to capture this portrait. When we expanded on the pose to create the kiss from baby's brother and sister shown in plate 226, the baby was falling backward into the arms of the siblings. This is a loving image, but at this point in the session, we were rapidly moving away from the desired format.

In plate 227, we tried a pose that is popular with both parents and siblings. Of course, having an older sibling hold a baby is risky. There is a chance that baby may be dropped and that the pose will be a ragged mess. In this example, however, the pose worked quite well—except that the sister lost her role in the portrait. We wanted her to place her left hand on her brother's shoulder in order to bring the composition together.

In the portrait shown in plate 228, the baby was seated on the boy's right knee so he could comfortably place his hands in a support mode. This allowed us to bring all three heads close together to complete the pose. This works quite well, so long as the child holding the baby is capable and understands his or her responsibility.

Plate 229 doubles up on the concept employed in the previous portrait. Here we have twin babies and three older siblings. Both brothers were positioned with the babies sitting on the knee nearest the center of the group. The boys were required to gently but firmly place their hands around the babies, both of whom were angled toward the center. Note the way the older children held the babies' tiny hands between their fingers. The babies' big sister was placed in the center of the composition to produce an undulating line across the group.

The portrait in plate 230 shows big sister seated with her legs spread so that she creates a safe support for the baby, who was seated and leaned against her. This baby was unable to sit without support and soon slid into a little heap in her sister's lap. Big brother was kept out of the mix, but his pose and position relate to the posing concept.

The portrait in plate 231 shows a group of seven. As you can imagine, with three babies and four children, this session presented some unique challenges. The two eldest children were placed at the end of the group and seated cross-legged and holding the two smallest babies. The nine-month-old baby was seated in between them, and you can see that though we sought to have her cross her legs, she could not hold the pose. The two younger girls were placed at the back of the group and centered. This is not a classic portrait, but it's a lot of fun and pleased the parents.

In plate 232, we tried something innovative by "stacking" the children with the baby at the base and the oldest child at the top. In such a composition, the baby is likely to crawl away—as this one was about to do. For this pose to work, each child must straddle the child below them and bring their head over his or hers as much as possible. Otherwise, the top child in the stack will be too far back for the camera to hold focus. Here, that position was achieved by having each of the two children at the top place their hands on the shoulders of the child below them. The child posed second from the bottom of the group then placed his hands on either side of the baby.

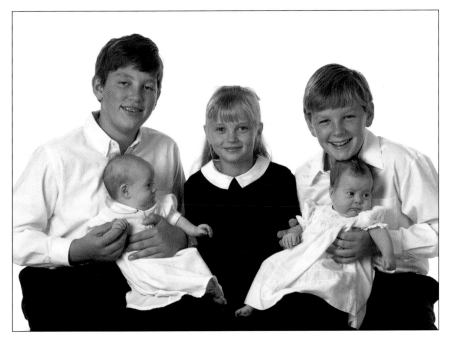

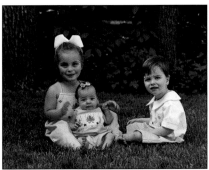

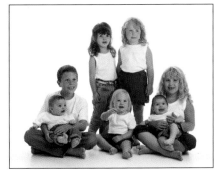

*Top—Plate 229. **Center left**—Plate 230. **Center right**—Plate 231. **Bottom right**— Plate 232. Photos by Norman Phillips.*

The same group of children is posed in a different style in plate 233. This time each child was posed on their tummy and rested on their folded arms. Though baby was capable of crawling away, we sought to have him do the same as his siblings; he stayed in place, so the resulting portrait works.

The same group is shown in plate 234. For this portrait, we had the two girls hold baby's hands and had each sister place their other hand behind baby so he did not fall. Big brother was posed at the back in the center.

In plate 235, we used a well-received and successful posing concept. The older sibling was positioned on the floor in profile to camera, and baby was placed on the back of the child. The older child rarely objects to this idea, and baby usually enjoys the pose. However, we may have to reposition baby a number of times before the session is complete.

Top left—Plate 233. *Top right*—Plate 234.
Left—Plate 235. *Photos by Norman Phillips.*

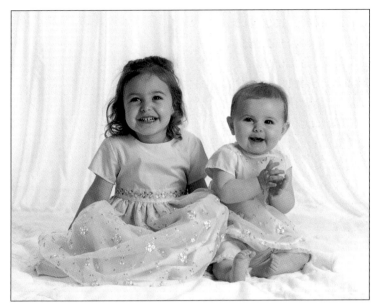

The portrait in plate 236 shows another pose that is simple to arrange. Baby appears very confident seated beside her elder sister, who was in a cross-legged pose. We originally crossed baby's legs, but they did not stay as arranged, which is quite normal.

When presented with two boys dressed in formal attire and a baby girl who was able to stand, we opted to arrange our subjects in the formal pose shown in plate 237. We positioned the boy in a seated pose to present him at a head height similar to his brother. We then positioned the younger brother and the baby sister at the arms of the seat. The older boy placed his right hand on the baby's hand to keep her where she was posed, and his left hand was allowed to relax in his lap. The younger boy simply stood with his right hand resting on the arm of the seat with his left hand behind him. The composition is simple but formal and suits their attire.

When we have a little person who will not stay in place we must resort to creative methods. To create the image shown in plate 238, we placed the little person in a box lined with a white fluffy blanket so that any potential sharp edges would not hurt him. He was not necessarily happy, but the arrangement works well in most instances. His sister was seated on a small seat at an angle immediately behind him so that her left knee was a little forward of the box. This allowed us to keep her close to the baby.

Engaging a small child in an activity with older siblings will often help us to produce successful portraits. This is illustrated in plate 239. A simple puzzle was placed in front of the two older children, and the baby was positioned so she could join the game without wrecking the set. This interactive concept works well as small children like to be involved with their older siblings.

Plate 240 shows an outdoor portrait of three children seated on a step in order of their age from left to right. By positioning them on the corner of the step, we were able to bring them closer together.

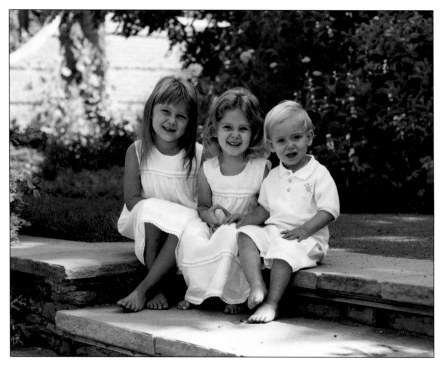

We did cross the subjects' feet at the beginning of the session, but only the older girl kept her pose. The little boy, under two years old, almost kept his position. Because the center girl wore a long dress that obscured most of her legs when seated, we still have an acceptable arrangement of their feet. Our arrangement of the hands almost held up, but not quite.

■ Groups of Girls

Generally, girls are much easier to work with than boys. Most tend to be calmer and more receptive to our posing ideas.

The twins shown in plate 241 were seated on a round ottoman. Both girls were turned very slightly away from the center to create a nice line from their knees to their toes. Note that their ankles were crossed to create a tapered line. The shoulder of the girl at our left was positioned just behind her sister's right shoulder. This narrowed the upper part of the composition, providing a slight triangular line from top to bottom. These girls were relatively calm, and their hands were passive and required no special posing.

In plate 242, we reversed the posing technique used in the previous portrait. This time we turned the girls toward each other, brought their hands together, and had them tip their heads toward the center. Note that we had them cross their ankles; this has been a constant throughout our discussions. Note, too, that we created a two-tier seating arrangement so that we could provide the younger girl with a base for her feet. This helped to ensure that once we had the ankles crossed, they would stay as posed.

Flower girls present the opportunity to pose elegantly as is shown in plate 243. Though we cannot see their feet in the portrait, they were posed

*Top left—Plate 240. **Top right—**Plate 241.*
Bottom right—Plate 242. Photos by Norman Phillips.*

according to the principles employed in previous portraits. The taller girl was positioned as the base for the pose. The smaller girl was positioned with her left shoulder just behind that of the other girl's right shoulder. This permitted the older girl to lean slightly toward her, bringing their heads together.

Each girl's hands were posed over the tops of the flower baskets, and their wrists were bent to achieve the "live swan" appearance (in contrast, the "dying swan" pose is achieved when the hands are allowed to drop below the wrist). Note that their baskets are not on the same horizontal plane and follow the lines of their shoulders. This provides a feeling of motion in the image.

In plate 244, we employed a casual pose as the girls were dressed in jeans and white shirts. Their feet were posed in a manner that is often used with boys, but the girls' personas created a different look to the feet position. They also had their free hands with thumbs hooked in their pockets, just as we have previously posed boys. Positioning the arm of the girl at our right on her sister's right shoulder brought their heads together, and the resulting portrait illustrates their close relationship.

Ask three girls to express themselves as only girls can and see what you get. Plate 245 shows the results we achieved when we issued that request. Note that all three subjects' feet are positioned relatively close

*Left—Plate 243. **Right**—Plate 244. Photos by Norman Phillips.*

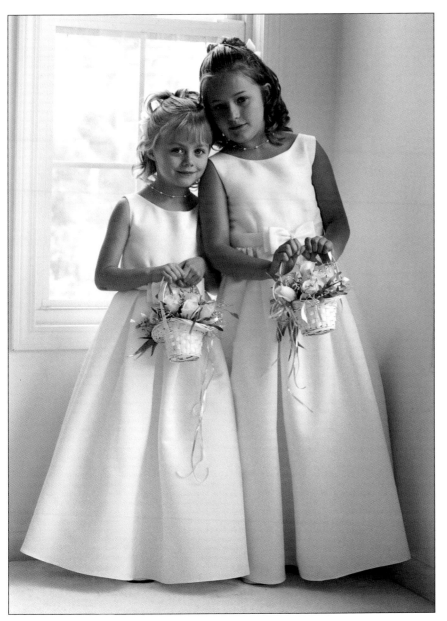

Top left—Plate 245. Top right—Plate 246. Below—Plate 247. Photos by Norman Phillips.

together, with the taller sister at the left and the shorter at the right of the portrait. This arrangement helped to unify the pose. In such a situation, as long as the clients keep their foot placements, whatever they do will generally result in an expressive portrait.

In plate 246 we used a pose similar to one we have oftentimes used when photographing boys. The difference is that in this pose, we had the girls hold hands, and with boys we would have them in a bear hug. We simply placed our subjects side by side and arranged their hands by having the older girl present the younger one with an open palm in which to place hers. The pose is simple and charming.

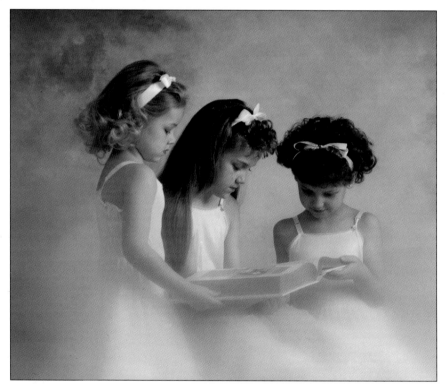

In plate 247, a large book was employed as a prop. Note that the lines of the book link the three subjects, and their mutual focus on the prop adds a storytelling component to the image. Two subjects were presented in profile, and one was positioned facing the camera. The resulting design has a very gentle sweep from the head of the subject on our left through the arm of the girl at our right.

A simple standing pose was ideal for the twosome shown in plate 248. The girls were slightly turned toward each other. This allowed us to present each girl's outer foot nearer to the camera for a nice presentation of the

feet. The girls then held hands and gently grasped a flower in the other hand. The flower was an important accessory as it gave them something to do with the outside hand, and we were able to dictate where the hand should be placed.

For plate 249, we seated three girls on a wicker couch with the youngest of them in the center. The girls at the ends each positioned one arm and shoulder behind the child in the center, and this drew them together. The child in the center was posed with her hands in her lap, and each sister brought her free hand across her lap. This created a sweeping pattern across the base of the portrait. A last-second instruction to have their heads touch completed the composition.

Plate 250 shows a completely different approach using two boxes as a posing prop. The girl on our left was first seated and then dropped onto her elbow and forearm and rolled onto her hip. Her right hand was then placed on top of her left to complete a circular line around her figure that leads back to her face. Her left leg was stretched out a little, with a pointed toe, and slightly rolled onto its side. Her right foot was placed immediately behind the other to create the desired tapered look.

The second girl was seated with her legs on the far side of the prop and drew her left leg upward. She then rested her left hand on the prop. The subjects' positions allowed them to tip their heads toward each other to complete the composition.

Groups of four, whether male or female, always present a design challenge, as we need to avoid having our group appear too symmetrical. In plate 251, we have a diagonal line of heads running from the top left to the bottom right. The fourth girl, the youngest, was snuggled in at the bottom

*Top left—Plate 248. **Center**—Plate 249. **Bottom left**—Plate 250. **Bottom right**— Plate 251. Photos by Norman Phillips.*

left of the group. This is not always the best presentation, as one head is immediately above another, but as the little girl was posed leaning into the shoulder of her eldest sister, we can escape without too much criticism.

Plate 252 shows a grouping of four serene ballet dancers. To compose the image, we had two of the girls seated on the wicker couch, one seated on the floor, and the last in a standing position. By placing the youngest girl at the left side of the seat and the eldest at the right end, we created a diagonal line from our left and upward to our right. Note the tapered lines we created with their leg positions; this is a constant throughout this book.

Plate 253 shows another group of ballerinas. To produce this dynamic design, we had the dancers employ ballet positions. The body angles we used create a nice circular line that starts at the hip of the girl at our left and travels over the subjects' heads to the tallest girl on the right. The linked hands tie the group together and completes the circular line.

Plate 254 shows four dancers in a dynamic composition. Each girl placed her hand on the shoulder of the subject to her right. The dancers on either end of the line assumed the same arm pose as the others, but with their

*Top left—Plate 252. **Top right**—Plate 253. **Left center**—Plate 254. **Right center**—Plate 255. **Bottom right**—Plate 256. Photos by Norman Phillips.*

palms upturned. All four girls have their right foot kicked over the left, and each girl's left hand—with the exception of the girl on her right—is placed at their hip. This is a simple arrangement that has lots of pizzazz.

Cheerleaders in their costumes are always fun to work with, as they are willing to try anything to create a great portrait. What makes it easy for us is that they are pretty flexible too. Plate 255 shows five of the girls posed in a line at the back. Note that instead of having a curved line across their heads I created a slightly undulating line.

Four girls were placed in front of the back five; the two to our right knelt on their right knee, and the two to our left knelt on their left knee. All four have the knee of their other leg bent, and the foot of that leg is placed on the floor about level with the calf of the kneeling leg. Each of the four placed a hand on their hip.

Another girl was placed between the four kneeling girls. The coup de grâce, however, is the girl at the front of the group. She is on her elbows and in a split-legged position that many girls her age can achieve.

Finally, in plate 256, we have a classic low-key portrait. The girls were posed behind a chair so they could rest their arms on its back. The girl to our left rested both forearms on the chair and placed her left hand near the elbow, which helped to create a nice presentation of the hand. The younger girl had her left hand on the knob of the chair back so that it almost touched the other girl's hand. This separation between the hands is important; without it, we would have too great a mass of skin tones.

■ Groups of Boys

Photographing boys, especially those four to eight years old, can be a lot of fun. We might be in for any number of surprises after we have them on our set. When two twin four-year-old boys arrived at the studio it was obvious that this would not be an ordinary session. So instead of showing a series of individual images, plate 257 is a collage of one of the sequences. The image speaks for itself. Boys will be boys.

Plate 257. Photo by Norman Phillips.

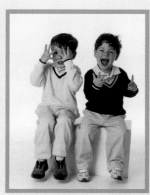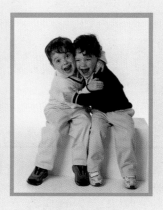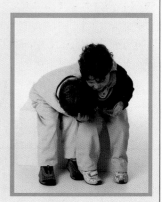

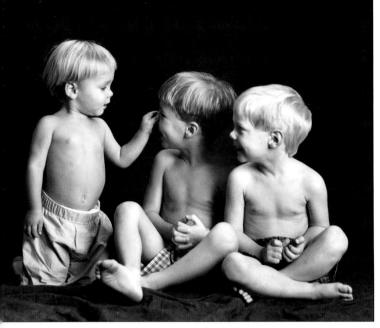

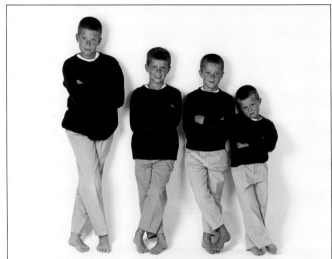

Continuing the theme of active and interactive portraits of boys, plate 258 has three shirtless brothers—two seated cross-legged and the youngest on his knees and pinching the nose of an accepting brother. All three were first seated cross-legged in a line in front, but junior had other ideas. Had he stayed in the original position, we would have had several options in getting the images we sought. We got this pose instead, and it's a gem.

In plate 259, we see four barefoot brothers positioned against a wall. When composing an image, I prefer to place the tallest subject at the viewer's left and the shortest subject at the right. For my senses it is easier on the eye.

Each boy crossed one foot over the other. For the sake of randomness we did not have them all cross the same foot and we did not correct each foot position as we would if we were photographing girls. All were posed with folded arms and leaned against the wall as boys are likely to do.

Note that the boy second from left has a different color sweater. We should avoid placing a subject wearing a different color outfit at the end of any group unless there is a special reason to do so as it draws immediate attention to that subject.

Plate 260 shows two barefoot brothers. The disparity in their age was crucial to creating this pose. The little fellow hugged his big brother, and the older boy placed his right arm around junior. Their joined outer hands kept the composition together. It is a fun posing concept that is ideal for boys.

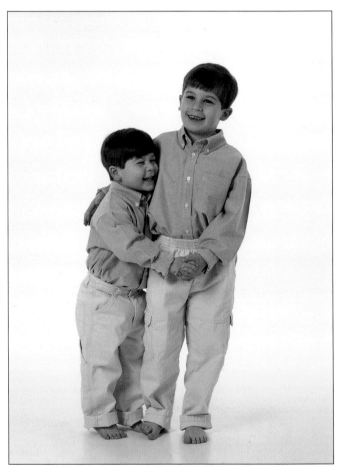

*Top left—Plate 258. **Top right**—Plate 259. **Above**—Plate 260. Photos by Norman Phillips.*

We stay with the fun stuff in plate 261. These twin brothers were originally seated side by side and, without notice or prompting, one decided to reverse his position and we obtained a truly humorous image. As previously stated, we can be surprised by the spontaneous actions of the younger boys we are photographing.

Plate 262 shows two brothers photographed at the beach, Note that each subjects' arms were differently posed. The older boy draped his arm around his brother's shoulders, and the younger child wrapped his arm behind his brother's back. Their hands were placed in their pockets to complete the pose. Boys find this a very easy thing to do, and it helps make the portrait very boylike.

Plate 263 shows three young brothers who held their floor pose throughout the session. At this young age we have little control over the children's hands. Though we begin the session with their hands placed in

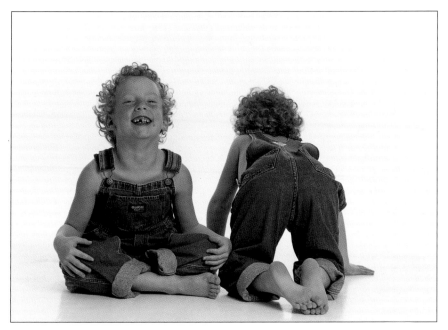

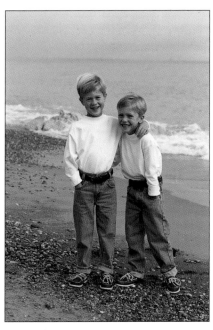

Above—Plate 261. **Top right**—Plate 262.
Bottom right—Plate 263. *Photos by Norman Phillips.*

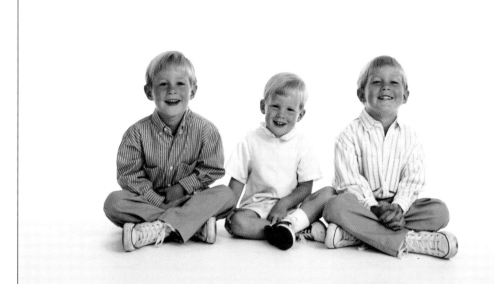

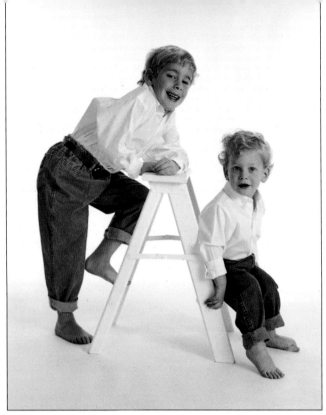

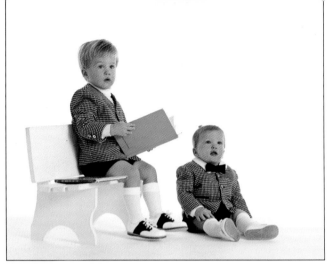

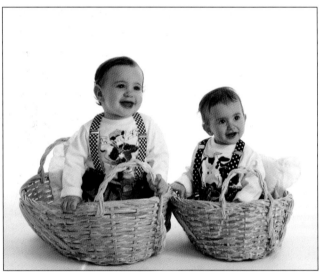

their laps, what happens to them during the ensuing few minutes often helps make the portrait childlike. With three young people we often use the see no evil, hear no evil, speak no evil game. Try it; you will be amused at the results.

Our little white ladder was again used as a prop to produce the image shown in plate 264. The little boy was seated on the crossbar that braces the back of the ladder. The older subject placed one foot on the low step and leaned his elbows on the top of the ladder. The pose is eminently simple and very effective.

In plate 265, two small, well-dressed boys are simply posed. One was seated on a bench, and the smallest was seated on the floor. The bench was angled at about 45 degrees off camera to show some bench instead of having it in side view, which would not make the composition as interesting.

Top left—Plate 264. Top right—Plate 265. Bottom left—Plate 266. Bottom right— Plate 267. Photos by Norman Phillips.

We have again employed a book to hold the older child's interest. The little boy is posed almost directly at the camera and shows the bottom of his shoes, something we normally try to avoid. We could have improved the portrait by having him a little more in profile to the camera.

The two little boys in plate 266 would not stay in place so we placed them in separate baskets. They were perfectly happy in their restricted space, and it produced a delightful portrait.

Our little white ladder was again used as the base for the portrait shown in plate 267. This time we had both boys standing on the lower step of the ladder. The youngest child will almost always insist on standing just as his brother does, and using such a pose keeps them together and in place.

The portrait presented in plate 268 shows another standing pose for two well-dressed boys. In order to present the clothes in the best-possible view (even though they did not fit in the first place) we had the older boy place his hand on his companion's far shoulder. The hands of their right arms were allowed to fall by their sides.

We discussed stacking techniques earlier, and we return to the concept in plate 269. This time we took a sideways view of the composition since the three boys were close in size, and if they were posed facing the camera, we would not see each face. Also, a sideways view is at least as interesting and as much—if not more—fun. Another valuable aspect of such a pose is

Above—Plate 268. **Right**—Plate 269.
Photos by Norman Phillips.

that when it turns into a fun-filled wrestling match we will be presented with some additional images that will truly represent the boys' relationship.

In plates 270 and 271 we captured some wrestling fun had by another set of brothers. Little boys can be a lot of fun, and we should never miss the chance to capture the moment.

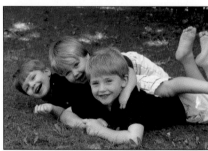

■ Boys and Girls in Pairs

In this section we explore different options for boy–girl pairs. Many of our posing decisions depend on the differential in the size of each subject in the group and sometimes also by what they are wearing. Casual attire allows for a certain freedom, while formal attire may limit our options since we may need to select poses that show the garments at their best. An additional influence is the style of portrait that parents wish to have.

The subjects shown in plate 272 were dressed casually for their session, so we simply posed them with their elbows resting on a tabletop. They cradled their faces in the palms of their hands, the boy with his fingers curled and the girl with a more feminine presentation with open hands.

Plate 273 shows the result of photographing a strong-willed girl and a easygoing younger brother. The elder sibling brought her dolls to the session, and we were obliged to prominently feature them in the portrait. All the dolls were placed immediately in front of her, and she placed her hands around them. We then simply positioned her brother at her left shoulder with his left hand on the leg of the doll nearest to him.

Plate 274 shows a close-up presentation of two children in a low key portrait, per the parent's request. The two children were seated next to each other, and we brought their heads close together and had the girl place her hand on her brother's shoulder. Note that by allowing the collar of the boy's shirt to show between her hand and his face, the hand does not draw attention away from the focal point of the image.

*Top—Plate 270. Above—Plate 271. **Bottom left**—Plate 272. **Bottom right**—Plate 273. Photos by Norman Phillips.*

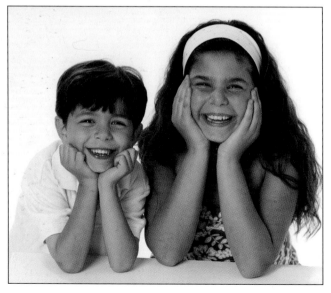

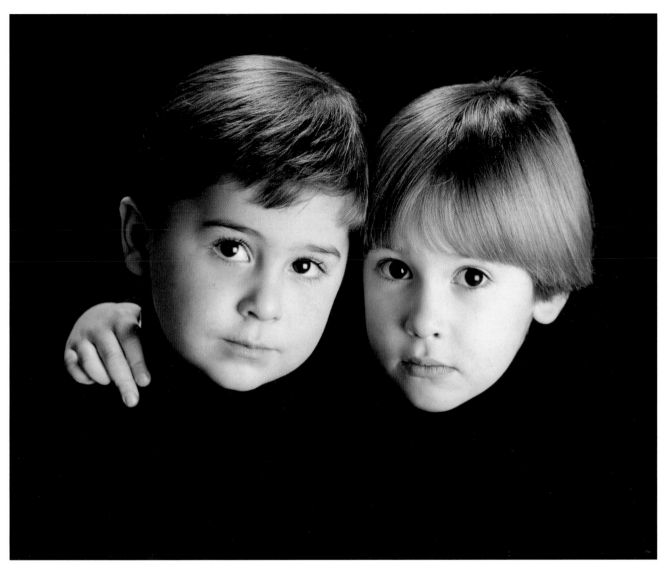

Above—Plate 274. **Right**—*Plate 275.*
Photos by Norman Phillips.

The portrait shown in plate 275 uses the elements of style we have previously discussed. The girl was seated at the base of the tree with her legs arranged as we have shown before. We then positioned the boy in a standing pose that was demonstrated earlier. Combining these elements made for a charming outdoor composition.

In plate 276, we return to a concept that was used to successfully pose two earlier groupings—one of two boys and another with a boy and a baby. This time we placed the girl on her tummy in profile and

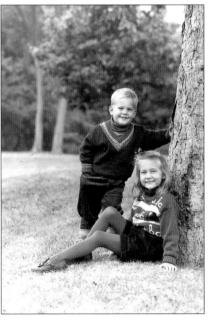

brought her younger brother over her so his hands could rest on the floor on the camera side of the composition.

Plates 277 and 278 show variations of the same concept. In plate 277, the girl was positioned over the boy, who was posed on his tummy and propped up on his left elbow. The girl rested her elbows on the boy with her chin in the palms of her hands. In plate 278, we kept the boy as in the previous portrait but brought the girl up onto his back so she could snuggle down.

Plate 279 shows two subjects in a standing pose, with the girl assuming the role of big sister. The boy's right hand was placed in his pocket, and his left hand was positioned behind his sister. The girl placed her right hand on the boy's shoulder and rested her left hand on her right hand to complete the pose. Note the feet positions. The girl assumed a ballet position,

*Top—Plate 276. **Bottom left**—Plate 277. **Bottom right**—Plate 278. Photos by Norman Phillips.*

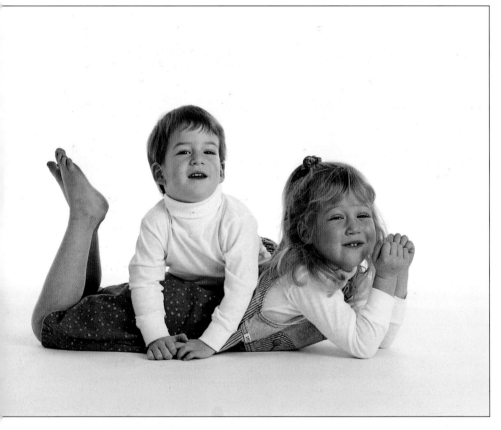

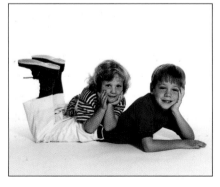
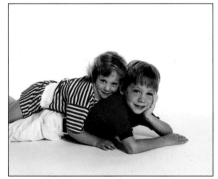

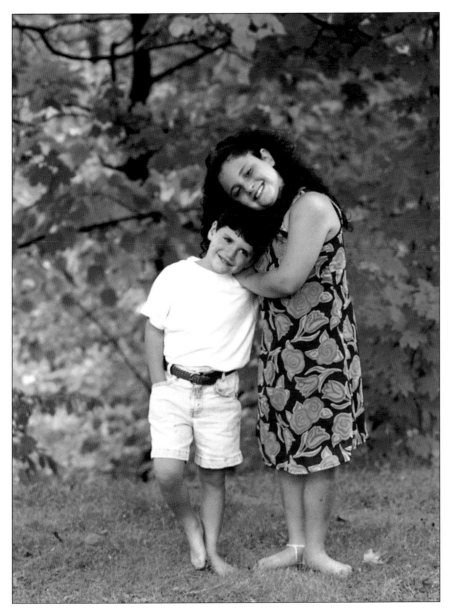

*Top left—Plate 279. **Top right—**Plate 280. Photos by Norman Phillips. **Bottom right—** Plate 281. Photo by Wendy Veugeler.*

and the boy modified one of our previous foot positions for boys.

At weddings we are often fortunate to work with little people as well as adults. In plate 280 a ring bearer and a flower girl are shown in a proactive composition. We had the boy sit on the window sill and positioned the girl on the radiator to create a diagonal line from the upper left to the bottom right of the frame. Note that the girl's left arm is outstretched and her fingers gently grasp the flower basket at her feet. This elongates the diagonal line in the composition. Note also that we had the subjects hold hands—*without* having one head above the other.

Plate 281 shows a portrait by Wendy Veugeler. The very simple posing concept allowed the brother and sister to demonstrate their love for each other. They were positioned with their shoulders together and were turned slightly inward so that their faces could touch. A more common pose of this kind would have them a little farther apart and turned less toward each other. In such a case, the boy's head would be tipped toward his sister, but in this case, he is shown in a more upright pose.

Plate 282 shows another portrait by Wendy Veugeler. This time the boy is depicted in a big-brother role with his little sister leaning against him. We should consider the dynamics of our subjects' relationship before we create the pose.

In plate 283, the subjects are presented in a different style. Each subject is turned slightly away from the other in a reversed presentation. We posed them so that their shoulders touched, and their heads were tipped toward each other for a delightful portrait. Boys are sometimes reluctant to get too close to their sisters. This may have been one of those cases, but because of the reversed positions we had no difficulty in getting the boy to cooperate.

The portrait shown in plate 284 departs from convention. These children are from a musical family and wanted to show off their talents. We simply placed them on the set, got the music going, and then recorded a series of action shots that the children thoroughly enjoyed—and we did too. This is another example of an image that uniquely suits the personalities of the subjects.

Left—Plate 282. Photo by Wendy Veugeler.
Top right—*Plate 283.* **Bottom right**—*Plate 284. Photos by Norman Phillips.*

Top—Plate 285. Photo by Cindy Romano.
Bottom—Plate 286. Photo by Kerry
Firstenberger.

■ Mixed Groups

As our groups of children grow in size from two to three and then four or more there may be some challenges in both composition and getting the children to hold their position, especially when there are one or more very small children in the group.

We begin this section with a discussion of plate 285, a truly delightful portrait by Cindy Romano. The beauty of this portrait is its simplicity. The eldest child was seated in the center of the frame with her head tipped slightly downward. The little girl and the boy were then placed beside her turned slightly inward, and their heads were brought together. It was important to have the two children at the side properly seated so they could place their inside shoulder slightly behind the shoulder of the center subject. The result is an appealing triangular composition.

Plate 286 shows a portrait by Kerry Firstenberger. To create this image, Kerry seated the two eldest children fairly close together and positioned their younger sister on a seat immediately in front of them so she obscured

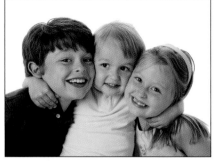

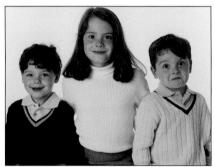

*Left—Plate 287. **Top right**—Plate 288. Photos by Kerry Firstenberger. **Bottom right**—Plate 289. Photo by Norman Phillips.*

the view of the inside shoulders of the older children. Next, Kerry brought the subjects' heads together for a result that is simple and yet charming.

Plate 287 shows another option we can use when posing a group of three. To compose the image, Kerry Firstenberger had the youngest child seated on a box with the older children on the floor, each with one hand on the box behind their sibling. The portrait is almost candid because of the leg positions the children assumed after they were originally positioned.

Plate 288 was taken when Kerry witnessed the spontaneous event pictured. The image simply documents a special moment that took place during the session. It is a truly delightful portrait that the subjects' parents will cherish.

Simplicity is the theme used to create the pose shown in plate 289. The two little rascals shown at either end of the image were shown earlier, and their older sister tolerated them to create this portrait. All three subjects were simply seated side by side, and the sister placed her hands on the back of each boy.

Normally I would not advocate presenting girls on their knees without showing their legs in a tapered pose, but if an idea works well enough, we can excuse breaking the rules. In plate 290, we sat the boy cross-legged then had the girls kneel close on either side and brought the heads close together. Though the hands are not ideally placed, we achieved the desired pattern in their hands and arms.

Plate 291 shows a trio of formally attired children. We wanted to create a relaxed but tidy composition. The boy was posed first. We had him rest his forearm and elbow on the prop and rest his chin on a gentle fist. Next,

his sisters were placed at his left and right to create a nice diagonal line from the top left of the image to the bottom right.

In plate 295, a high white stool was used as the base for the composition. First the boy was posed with folded arms resting on the stool. The two girls were then positioned on either side of him, with each girl's inside hand placed behind the boy and their outside hand placed on top of the stool; this created a nice base for the beautiful faces. Should we have a group of two boys and one girl, we can use this same composition with the girl in the center.

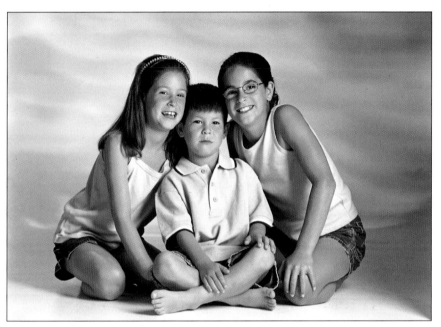

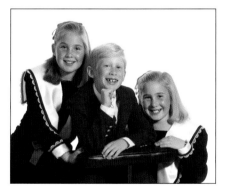

*Top right—Plate 290. **Above**—Plate 291.*
Bottom right—*Plate 292. Photos by Norman Phillips.*

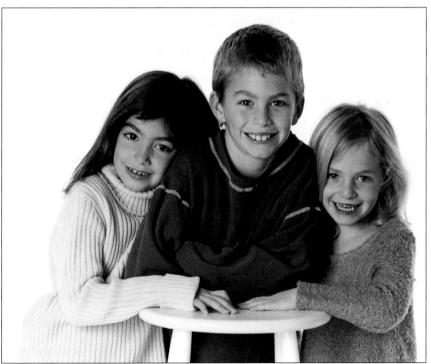

Plate 293 shows three children posed by a forked tree. The boys were positioned on either side of their giggling sister and rested their inside hands and arms against the tree. The hands of their outside arms were tucked into their pockets. Because the boys were in a very casual pose, we did not insist on a traditional pose for the feet. The young girl leaned against the fork in the tree and folded her arms. Her ankles crossed to ensure a tapered presentation.

In plate 294, we have three children huddled together on a park bench. We had the two boys bring their knees up; the boy on our left hugged his knees and his brother rested his left hand on the bench. The little girl was then tucked into the space we created for her. Finally, we placed her left hand on the younger brother's left shoulder and her right hand on his arm.

Four small children in their pajamas are featured in the portrait shown in plate 295. The key subject in this composition is the older girl, who is centered and on her left hip with her legs extended to our left. Her left arm acted as a support for the smallest child, who was seated at her shoulder. The little girl was then placed beside the little person, and we placed his hand in hers. We then had this little fellow where we wanted him. Lastly, the older boy was placed at the oldest girl's shoulder with his left hand resting on the floor behind her.

Top left—Plate 293. *Top right*—Plate 294. *Above*—Plate 295. *Photos by Norman Phillips.*

Plate 296 shows a portrait of a fun group of four children caught in a moment of pure laughter. They were placed so that their respective heights create an undulating line of heads. Note that we also have a diagonal that involves the three to our left. The boy in black held the smallest child so that he stayed in place. The girl placed her left hand on the same boy's shoulder to create a visual connection between them. The boy on our right positioned his hand behind the boy in black. His left hand was posed on his belt.

Plate 297 shows the same subjects in a variation of the previous pose. The small boy was placed at the front of the group so his head was not immediately below the two children behind him. We had him hook his thumbs in his belt. The girl to our left placed her hand on his shoulder, and the boy at the back placed his hand on the left shoulder of the girl next to him. The final subject—the girl on our right—was posed with her hands clasped simply in front of her. This particular hand position is okay for girls but is not acceptable for boys or men. Again, note that we have a diagonal line in the composition that runs from the top left to our right.

Plate 298 shows three girls and their toddler brother, who was keen on leaving the set. All four subjects were positioned in a standing pose, with the youngest at our left and the eldest at our right. This produced a diagonal line from left to right. The toddler was placed last, and his hand was held by his eldest sister. To finish the portrait, we asked that all of the girls hold hands. Simple posing compositions often are the most appropriate.

*Top left—Plate 296. **Right**—Plate 297. Bottom left—Plate 298. Photos by Norman Phillips.*

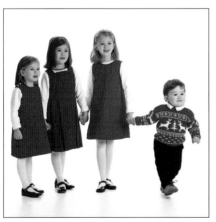

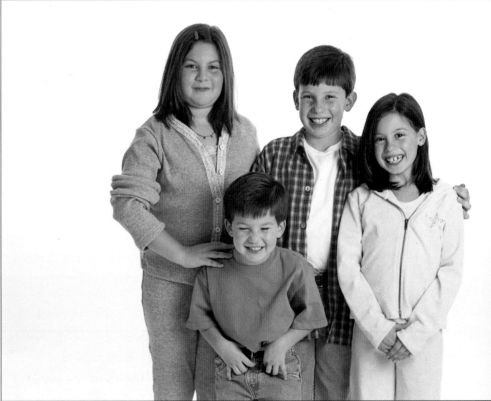

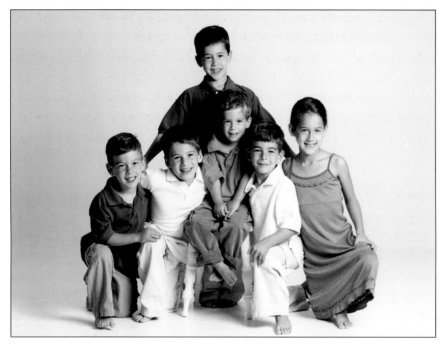

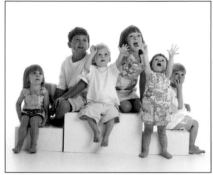

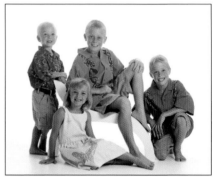

Plate 299 shows a portrait of six children. To create the pose, we first positioned the youngest child on a stool and surrounded him with his brothers and sister. All the children in the front knelt on one knee; the two on the left were posed on their left knee and the two on the right on their right knee. The eldest boy was placed at the back as his height allowed us to see him clearly. His arms were outstretched and his hands were placed on the backs of the two children at the ends. Note that the two wearing white were placed between the children in darker attire.

A little chaos is expected when we must photograph a group of six children—especially when there are three young children involved. Plate 300 depicts such a situation.

To compose this image, we tried to position the subjects in a nice arrangement and keep their attention. We arranged a set of risers in such a way that the center platform was taller than that used at the back of the composition. This enabled us to create an undulating pattern across the heads. The two elder children were seated on the higher block with the smallest child positioned immediately in front of them. The others were positioned in the best place for their size, but as you can see, using bubbles to attract their attention toward the camera caused some expected chaos.

To produce the portrait shown in plate 301 we had to get a little creative. We used a curved prop on which to pose the eldest boy with his left knee pulled toward him and his right leg placed on the floor in front of the prop. His left hand was placed on his high knee and the other on his right thigh. Next, we placed the girl on the floor in a similar pose. By positioning her upper leg in front of the lower one, we were able to create the tapered line we desire. The second-eldest boy was positioned in a kneeling pose, with his right knee down so that it is partially hidden. His right arm

*Left—Plate 299. **Top right**—Plate 300.*
***Bottom right**—Plate 301. Photos by Norman Phillips.*

rested on the prop. Finally, the youngest child was posed at the high end of the prop and rested his hands on the top of it. The total composition has a nice undulating line over the heads, and each child is in their own unique pose.

We return to the stacking posing technique in plate 302. This strategy works really well when your subjects range widely in age because the difference in their heights makes the pose easy to accomplish. In this image, the subjects ranged in age from eight months through fifteen years. We can see everyone's feet except the baby's, and the oldest child had enough height to be able to rest his elbows gently on the sibling in front of him.

Plate 303 shows a portrait of seven children ranging in age from four to fifteen. We had two goals in designing the posing concept: first, we needed to accommodate the difference in the color of the subjects' clothing; second, because the eldest males were very tall, they would have towered over the rest. To solve these problems, we created a nice even spacing between the tones by separating the subjects in darker colors and seated the two teen boys to reduce the discrepancy in the subjects' height. You might suggest that we should have had the tall girl at the right in the place of one of the two boys in the center, but I prefer a girl like this to decorate the end of my composition. Also, placing her at the far right allowed us to break what would otherwise have been a simple curved line across the group.

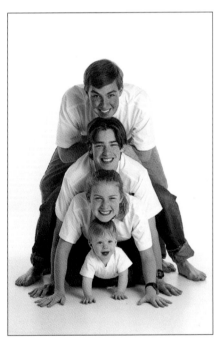

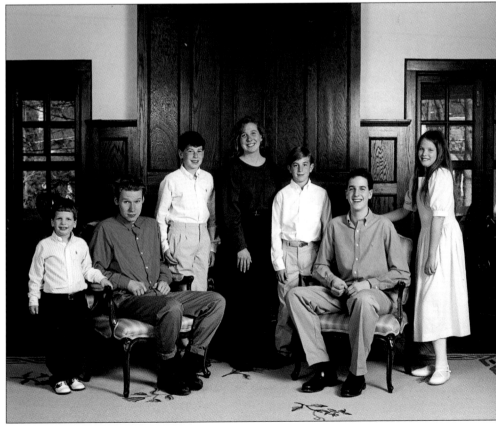

Above—Plate 302. ***Right****—Plate 303.*
Photos by Norman Phillips.

In the late 1990s, angels were a popular theme in children's portraits. Many photographers simply affixed angel wings to their little subjects' backs to produce portraits that were cute and perhaps a little artsy. Here, we show two images that take the concept a step farther. The children's positions work well with the angel standing over them, but note that if she were eliminated, the posing concept would remain effective.

In plate 304 the children were arranged according to their age, with the youngest at the left of the composition instead of the right because the title of the image was *Prayer and Curiosity,* and I wanted the line to lead you to the inspiration of the portrait. It is a simple concept and successful in its objective.

Plate 305 has a completely different design with each figure individually posed within the total composition. We have two diagonal lines within a triangular composition and we are drawn to the baby girl, whose interest was sparked by what was going on in the set.

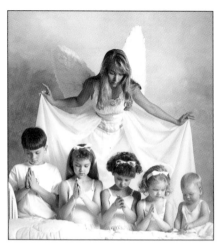

*Above—Plate 304. **Left**—Plate 305. Photos by Norman Phillips.*

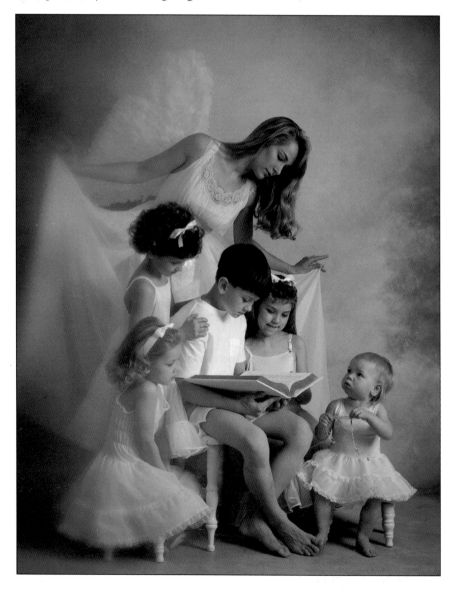

Conclusion

This book has over three hundred posing examples, yet it is likely that there are countless others that we could show if space was not an issue. But what we have shown presents a solid portfolio from which to expand your posing techniques. We have covered the simplest of concepts and the more complex. All of them are usable at some point in our work with children and babies. I am sure that when you have reviewed all that we have discussed, you will be able to expand your range of posing styles with the hints and suggestions in the preceding chapters.

But I would counsel you to adhere to the principles of good posing whenever it is feasible. The positioning of feet and hands and the expression of body language is critical to the success of your portraiture. We should never be lackadaisical when posing our individual subjects or when we are creating groups portraits. Attention to detail is important, and too often not enough is applied to portraits. When we fail to attend to detail we might assume that our clients will not know the difference. If you really believe this, I can assure you that you are wrong. A client may not know *why* a portrait is not what it should be, but they will know it is not what it should be. By the same token, our clients know that what we create is good and more than acceptable when we discipline ourselves in the art of posing and composition.

> THE POSITIONING OF FEET AND HANDS AND THE EXPRESSION OF BODY LANGUAGE IS CRITICAL TO THE SUCCESS OF YOUR PORTRAITURE.

While some will advocate that good posing is an art, and to a degree this is true, good posing comes from recognizing good from not so good—and bad from not so good. Practice and observation are vitally important. We can all get better at what we do by not accepting anything we know is not good enough and being critical of all that we do. If we always examine what we do with care and thoughtfulness, we will become our own teachers. We can also ask our colleagues to critique our work and offer suggestions and advice. We can never stop learning because we can never know all there is to know, and when it comes to posing and composition of groups, there are so many options and ideas from which to work, our creativity can only get better.

Index